This book is dedicated to my daughters Ayse &
Zeynep Meric and my husband Artabano Forcellese,
for their patience and support.

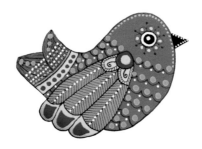

Bibliographical Note

The Art of Stone Painting: 30 Designs to Spark Your Creativity is a new work,
first published by Dover Publications, Inc., in 2017.

Library of Congress Cataloging-in-Publication Data

Names: Bac, F. Sehnaz, author.
Title: The art of stone painting : 30 designs to spark your creativity / F. Sehnaz Bac.
Description: Mineola, New York : Dover Publications, 2017.
Identifiers: LCCN 2016038523| ISBN 9780486808932 (paperback) | ISBN 0486808939
Subjects: LCSH: Stone painting—Technique. | BISAC: CRAFTS & HOBBIES / Painting. | ART / Techniques / Painting.
Classification: LCC TT370 .B33 2017 | DDC 745.7/23—dc23 LC record available at https://lccn.loc.gov/2016038523

Manufactured in the United States by LSC Communications
80893903 2017
www.doverpublications.com

The Art of Stone Painting

30 Designs to Spark Your Creativity

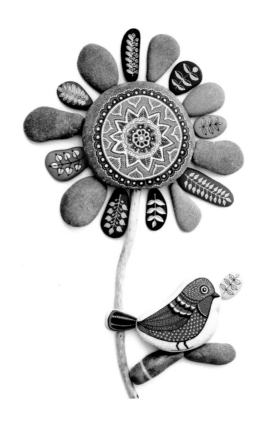

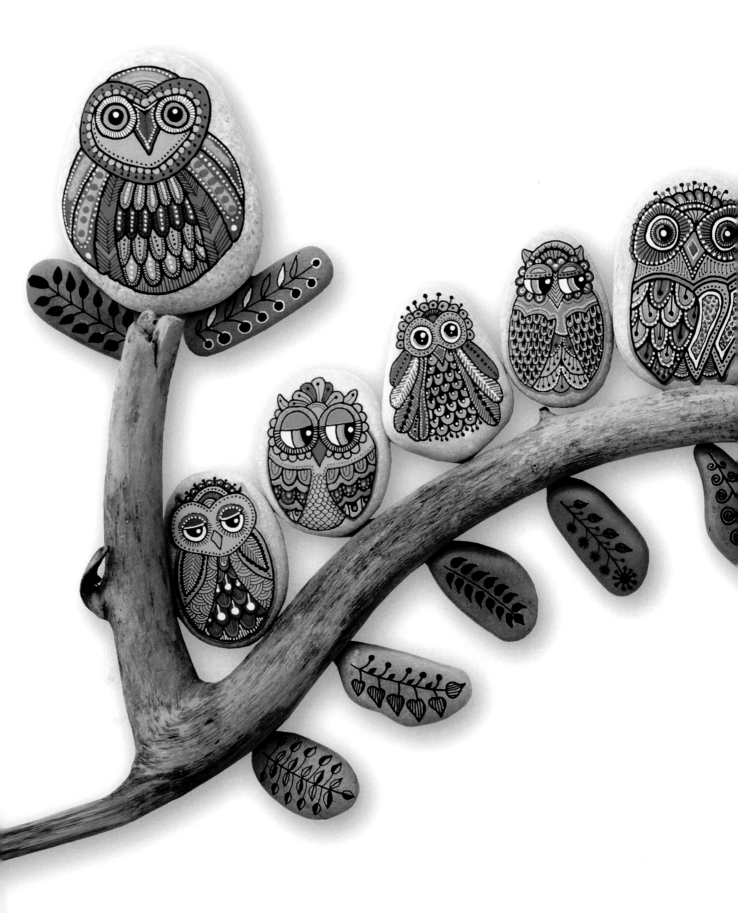

The Art of Stone Painting

30 Designs to Spark Your Creativity

F. Sehnaz Bac

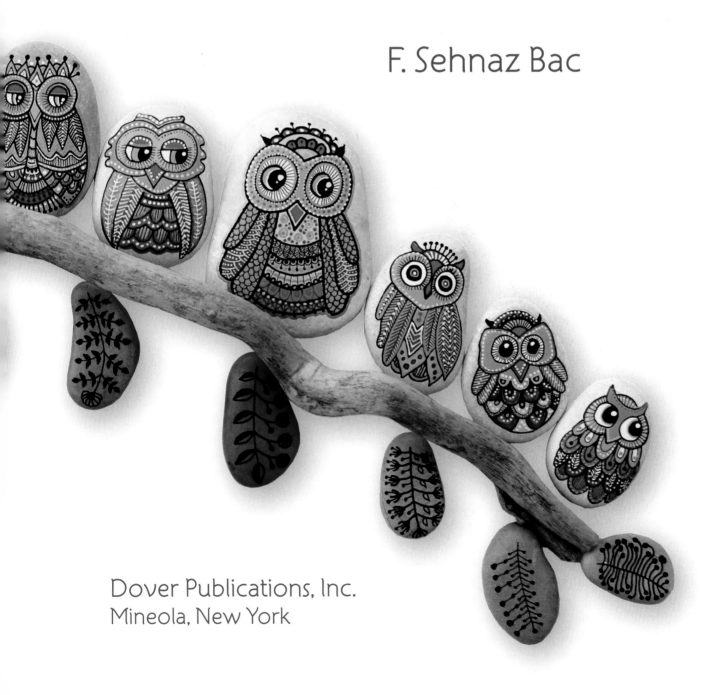

Dover Publications, Inc.
Mineola, New York

Table of Contents

Introduction

Stone painting has become increasingly popular in recent years. It can be a rewarding pastime for all, and it can even help some cross the bridge from a simple hobby to actual art. The stones you'll use for painting are easy to retrieve; they can often be found during nice walks in natural surroundings. The finished products can help to decorate gardens and vases, or can be kept on a desk or any piece of furniture. You'll feel the relaxing influence of nature within your household whenever you look at them.

Stone painting is for all. There is no artistic experience necessary. Anyone can learn—grownups and children alike—and not only are the materials easily accessible, they're also inexpensive.

The beauty and enjoyment of the stone-painting process lies in the "canvas" offered by the shape of each stone, which dictates the traits of any final design, stimulating the creativity and imagination of each painter. This close relationship is almost like a communion—an intimate rapport with the stone itself that will guide you through the whole painting process within its limited space.

More and more people approach this form of art which, aside from its artistic value, bestows serenity, peacefulness, and tranquility. Simply touching and handling the stone can bring on feelings of relaxation.

In this book you will find many beautiful and fun stone-painting projects. Because I like to draw and paint my designs in a stylized way, using my imagination, you will come across different animals, such as whimsical owls, colorful birds, butterflies, dragonflies, and peacocks. You will also find some flowers and plants that don't even exist in nature. I believe this kind of stylized design helps you to increase creativity and create one-of-a-kind artwork.

The book will also guide you toward finding your own way to paint, without worrying about your artistic skills. As each stone is unique in nature, in the end you will create your own unique works, trying the techniques explained here.

Your finished designs will bring additional happiness into your home—especially if you give them as gifts to the people you love!

Like me, I hope you will cherish your time painting stones, and will get the utmost joy and satisfaction out of this wonderful leisure pursuit.

FINDING STONES AND HOW TO CHOOSE THEM

To start gathering stones, one place you can try is the seashore. Here, depending on the type of beach, you will be able to collect different sizes and shapes, in a variety of shades.

However, it is along a river where you will have the best opportunity to pick up beautiful stones. The constant flowing water will have worked wonders on these pieces, making them beautifully round and flat, consistent, and smooth to the touch, from the smallest to the very large.

The river delta and its surroundings and some lakes are also ideal; these areas will be precious "stone mines" where you will have an almost never-ending choice. Just make sure, like anywhere else, of the legal aspect that may apply to gathering and removing a natural object from the area.

When you start to look for the right stones, generally it is important that you already know which project you are going to use them for. If you already have your project in mind, you will look out for stones and pebbles with the suitable shape and size. But you always have the alternative to collect all the stones you like first, and then find the inspiration for some different

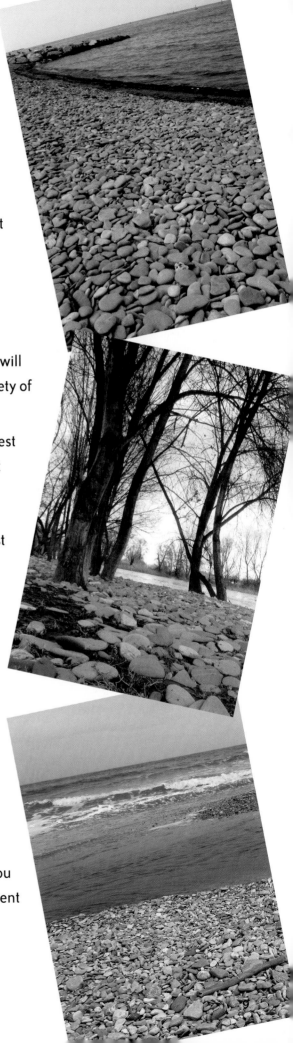

projects after. Don't forget, any stone you come across and want to collect can become a unique piece of art by applying your creativity.

However, when you choose the stones to collect, it is always better to go for the ones with a smooth surface, so you will not have problems when drawing and painting on them. If you come across some smooth black stones and pebbles, make sure to collect some of those too—they work beautifully with monochrome designs.

Going stone hunting will make your day fully enjoyable, and your family can even join you in this pursuit. It makes for a lovely, relaxing, and healthy activity for all.

If you live far from seashores and river banks, don't worry—you'll be able to find stones in any do-it-yourself shop, home store, or garden supply store. They usually come in small bags, in a variety of shapes and colors.

HOW TO PREPARE STONES FOR PAINTING

Before painting your newly found stones, you have another step to complete: All your stones and pebbles will need to be cleaned thoroughly.

After you bring them home, leave them in water for a few hours in order to fully rid them of any dirt. Next, with the help of a soft toothbrush and some mild soap, wash them under running tap water. Let them dry in the open air under the sun for at least a day, depending on the porosity of the stones.

Although for the very smooth stones you will need to take no further preparatory action, it takes a little bit of extra dedication for those porous stones you have decided to use because you really like their shape. With some extrafine-grit sandpaper you will gently rub the surface, focusing on any small bumps. After you are finished sanding, remove any residual dust with a damp cloth or brush.

Should the stone still be too rough, you can always apply two coats of white acrylic paint, pressing the brush down in order to allow the pores to take in the paint and create a surface that's as even as possible. Once the stone is completely dry, you will gently sand it down as described above.

I suggest using white acrylic as a base to enhance the colors you will later use to decorate the stone, because acrylic colors tend to darken when they dry out.

TOOLS AND MATERIALS

Now that you have your stones prepared, you can get to work. So let's learn which materials and tools you'll need and which ones suit you best. To paint the stones, you only need to make a very small investment. Some paint brushes and acrylic paints will be enough to start with for the easier projects.

Brushes

Paint brushes have different sizes and qualities. It is always better to choose good quality brushes; they will last longer and will give you far better results for the projects you will find inside this book.

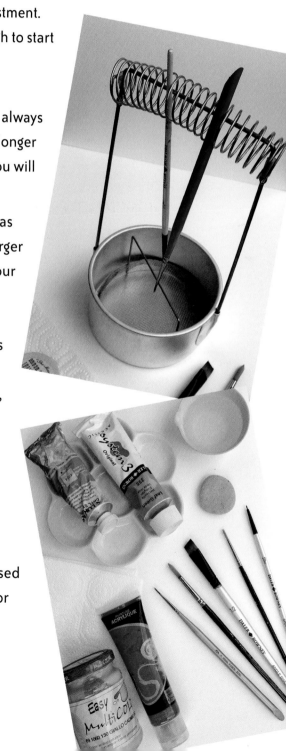

You will need round brushes in different sizes, such as 1, 2, and 3; and for details, sizes 0, 00, and 000. For larger surfaces, use size 14 and 16 brushes. Always wash your brushes with warm and soapy water after you finish painting. You can use art products (brush soaps) prepared specially for this. Never leave your brushes inside your water bowl; this will ruin their shape. It is better to hang them vertically after you wash them, hairs down, without touching the end to any surface. You can use a brush holder for this, which is also useful as water bowl.

Paints

Acrylic paints are the best for stone painting. They come in brilliant and vivid colors, and are easy to apply. Alternatively, you can use any other water-based craft colors. Acrylic paints come in tubes, glass jars, or

plastic containers. It is important to keep in mind that they dry very quickly, so always keep them closed when they're not in use. If you want to mix your paints to create different colors, use small quantities on your palette. Even if the paints are odorless, try to ventilate your working area during the time you spend there.

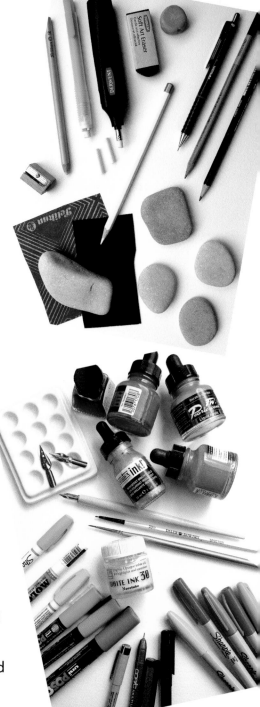

Pencils

You will need hard lead pencils to sketch your designs on stones. Use pencils with a hardness of at least 2H. This is because you will not want to smudge graphite on your stone; it will be difficult to clean. For any mistake, use a soft art eraser. To sketch on dark stones, use a white colored pencil.

Paint Pens

Once you are ready to switch to a more sophisticated design project, paint pens are a good choice. They are easy to use and best for detailing your stones; they even work well for more complicated designs. Most of them use a push system to release the paint, so shake them well before each use. They come in different sizes such as small, fine, medium, and large; some of them also have extra-fine tips, which are necessary to paint small areas on your design or colored line art. You can choose any size, depending on your creation. You can also use different marker pens for your designs to give extra effects to the colors you choose.

Acrylic Inks

Acrylic inks are also very useful when you paint your stones; they have intense colors with good quality pigments, and you can use them with small thin round brushes or with dip pens for a more detailed look.

Fineliner pens are a better choice when it comes to detailing your designs

on stones. Most of them have archival indelible ink, and their extra-thin sizes, such as 0.05, are very useful for adding tiny details. When you use them over painted areas, make sure your painted layer is completely dry so the ink will not mix with the paint.

Other Materials

If you are unsure about your ability to draw or paint on your stones, you might decide to trace a design using templates. You can use transfer paper for this work. Different types are available, such as carbon transfer paper for lighter surfaces and white transfer paper for darker surfaces. Use these papers carefully, because when you make errors it is very difficult to remove them with an eraser.

A cup of water to clean your brushes, some paper towels, and a palette for mixing your colors are the other materials and tools you must have near you when you paint.

To protect your creations you will need water-based varnish; according to your taste you will choose between glossy or matte finish, which you can apply with regular brushes. Alternatively, you can use a spray varnish.

STONE PAINTING TECHNIQUES

When your stones, materials, and tools are ready, you can start to paint! You will find 30 projects in this book; I generally use the same techniques throughout. Sometimes those techniques are similar, sometimes they are a little different, but essentially they are the same methods you will read below.

Basically, you always have two choices: You can start to paint directly on the natural surface of the stone, or you can paint the whole surface of the stone first, and after it is completely dry you can start to work on top of that painted background.

Now it is time to sketch or outline your design. If you are not so sure about your design, sketch it first on paper to see how it comes out. When you are happy with it, outline the design on your stone with a hard lead pencil. Use an eraser if you make some errors. Try to have clean pencil lines on your stone.

If you are finding it difficult to create a design with your imagination, you can draw inspiration from books, the Internet, or creative friends. Download or scan what you find, and adjust the size with a photo editor program until it fits on your stone's dimensions (if you think you might sell your creations later, make sure to use copyright-free designs). Then print it, and using the transfer paper, trace it on your stone's natural or painted surface.

Once your design's outline is ready, you can start to paint it. Fill the parts of your design with acrylic paints and paint brushes, or acrylic inks with thin brushes. Wait at least 10 or 20 minutes (or use a hairdryer with warm air) for the paint to dry completely.

Then using fineliner pens, draw the outline of your designs. This is quite optional—even I like these kinds of contoured designs, but you can leave your design without an outline. For a clean look, make sure to cover all pencil traces. Wait for another half hour for the ink to dry. Even if it's not your first thought, drawing a bold, black outline around your painted areas will make your designs really stand out.

Now you are ready to add details to your painted and outlined design. You can use fineliners with different colors, paint pens of different sizes and colors, acrylic inks with tiny brushes, and dip pens with different-sized tips for this detailing work. When adding details to your designs on stones, the possibilities are endless. You can try to use all your materials for these details, or you can go with only one kind of material. Every different try will give another look to your stone. After a while you will be able to choose whichever method and material is better for you and for your own style, often mixing techniques as you go along. Adding the small details to your creation is a lot of fun. Try thin lines, circles, dots, semicircles, triangles, and squares.

All the techniques explained above are applicable to all projects presented in this book, although you will find that some of them come with more detailed step-by-step instructions.

For mandala or monochromatic designs, I work directly on the stone's surface, starting from the center outward, and adding lines, circles, and semicircles with

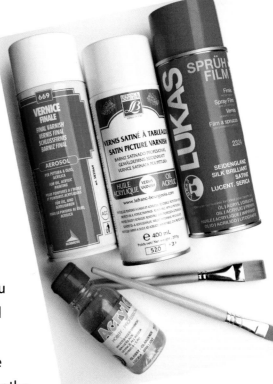

a steady hand and regular movements. This type of work requires extra attention for a neat result.

Once you have completed your creation, let it dry in the dark for 24 hours.

SEALING AND PROTECTING PAINTED STONES

Once your finished decorations are completely dry, you will need to protect them from atmospheric agents and aging in general. I always do this, even if my stones are kept indoors. Acrylic colors are indelible, but with time and adverse conditions they can lose their brilliance, or the design can be accidentally damaged by mishandling.

You can use acrylic varnish in liquid or spray form, and in both cases choose products that contain UV filters for extra protection. This varnish will seal your design on the stone and add a final, perfecting touch to your creation, increasing its visual impact. Apply two or three coats of liquid varnish with wide brushes, always waiting at least a couple of hours between each layer.

If you use spray, do it outdoors and wear a mask to avoid inhaling the fumes. Protect the surface you have laid your stone upon, spray from at least an 8-inch distance, and always wait a number of hours between each coating. Always bear in mind that spray is highly flammable; therefore, be cautious and keep any ignition sources away from it.

On stones that are going to be positioned outdoors, it is always better to apply an extra coating of varnish in order to protect the stone from various atmospheric agents. Four or five layers of varnish are recommended.

With both methods you will pick either glossy or matte varnish, depending on your taste. However, with some designs, like fish, for instance, I recommend using the glossy finish, whereas with the more detailed mandalas a matte varnish will be more suitable for a stylish, artistic look.

Now your stone is ready for its final destination!

HOW TO DRILL STONES

A stone is a beautiful natural object by itself, and it will be even more beautiful once it's decorated and becomes an ornament such as a pendant. In this case you will want to try and drill a hole in it and affix a small ring. For this job you will need a few tools and materials. The most important being a rotary tool such as a Dremel with a series of small diamond tips (between 1.5 and 3 mm) and a vise to secure the stone you are working on. To avoid possible breakage, choose a uniform stone with no veining or small holes.

Safety is important: Make sure to always wear a pair of goggles and a mask to protect yourself from dust and flying bits.

With a pen or pencil, apply a dot on the point you decide to drill on, and start working with slow, steady, and light pressure. Go in small increments, setting the drill at average speed. Do not hurry—you will need lots of patience for this job.

Once the hole is completed, you will insert the ring with the help of a pair of pliers and fix it with superglue, waiting 48 hours for it to dry. Then you can start painting your stone.

SHOWING AND USING YOUR PAINTED STONES

You may want to give your painted stones to friends, relatives, and colleagues as gifts; they will appreciate its uniqueness tremendously, realizing it's handmade with your love, creativity, and imagination.

You can use them to decorate your own home: on a book shelf, on your coffee table, or to enrich and garnish a special dinner table or buffet. They can be shown off aligned on a window sill, or you can even create a framed, wooden display panel by arranging and attaching the stones on it with hot glue or superglue,

choosing smaller stones for their lightness. This will make a unique decorative object for your wall.

Depending on the size, stones can also be used as book stops, door stops, or as a paperweight on your desk. Their presence in your home will surely bring additional harmony and happiness, as well as a decorative touch.

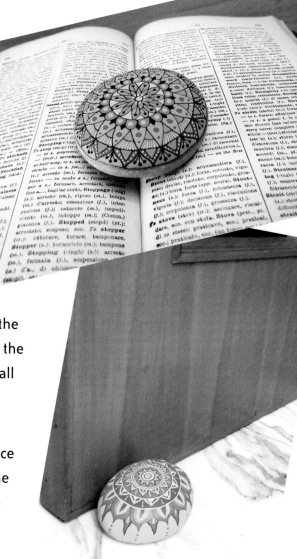

Properly coated with varnish as described earlier, the painted stones can also be placed next to plants in the garden, directly on pots, along a path, or near a small fountain.

Smaller stones can be glued to magnets: You can work out lots of funny, humorous designs and place them on your fridge. Small stones can also become jewelry such as brooches, pendants, or rings with the correct findings.

These are only suggestions. I'm sure you will use your imagination and find many more applications for your future creations!

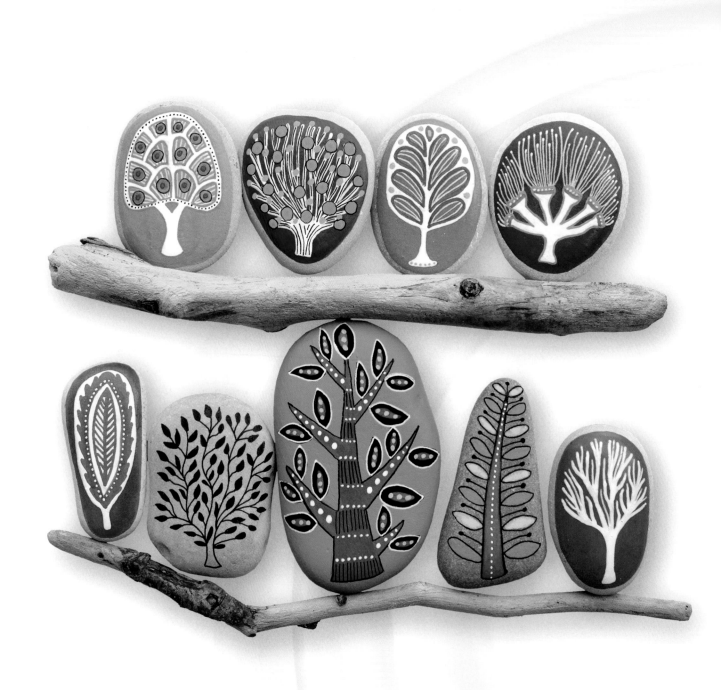

Flourishing Trees

1 Trees come in many shapes and sizes, and can therefore be painted on many different-sized stones. To start, you will need a stone that has a smooth surface. Here I used a medium-sized stone (1–2 inches).

2 Near the edge, draw a line around the stone with a pencil. Fill this space with the acrylic paint color you prefer. Here I used dark green.

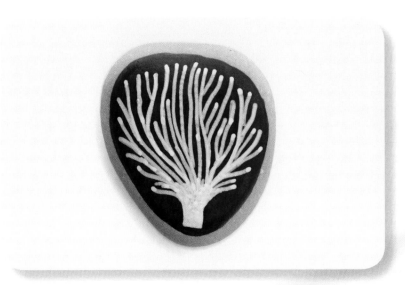

3 Draw a simple tree design directly on the painted area, using a thin round brush and white ink (or with a white paint pen).

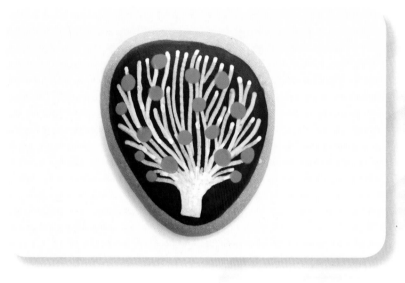

4 Now you can add some details to your tree. Paint some light green dots on different parts of the tree.

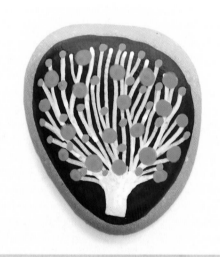

5 Continue to add details with some pink dots; make them smaller to have a balanced look.

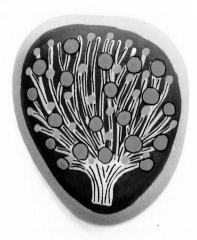

6 Using black ink, draw some contour lines around the green dots and branches to make your tree more stylish.

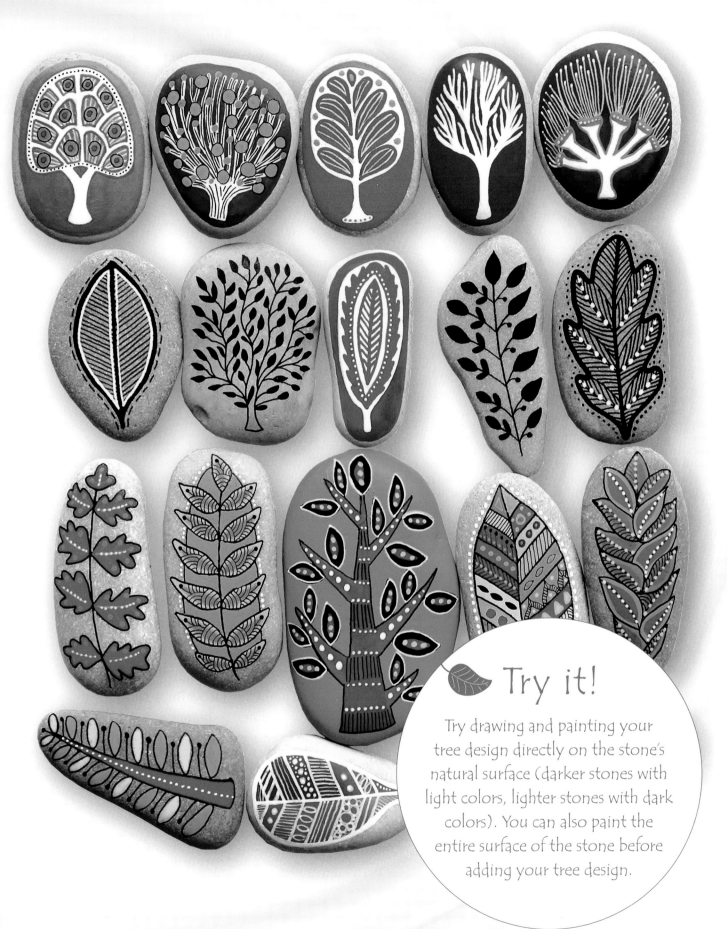

🍃 Try it!

Try drawing and painting your tree design directly on the stone's natural surface (darker stones with light colors, lighter stones with dark colors). You can also paint the entire surface of the stone before adding your tree design.

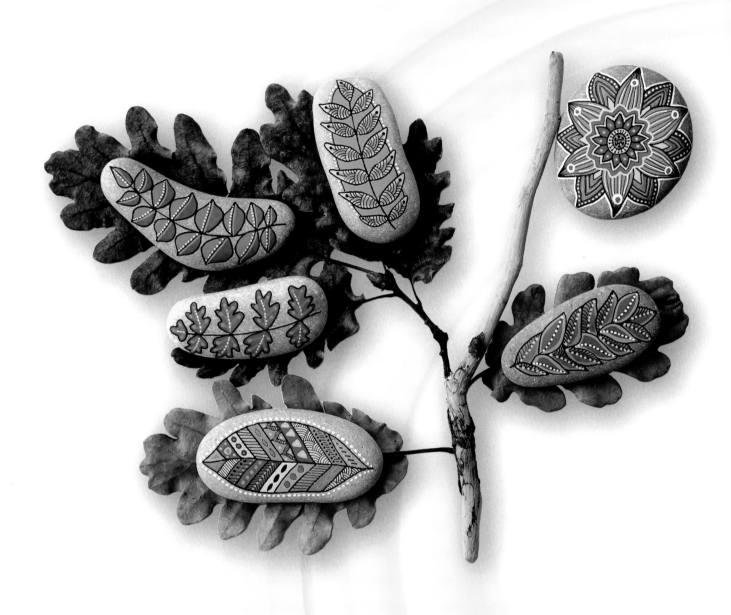

Leaf Collection

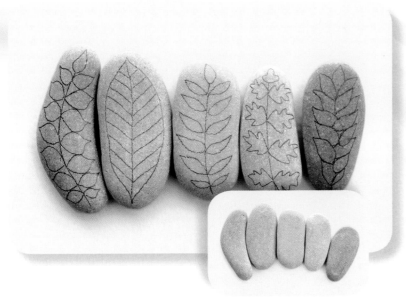

1 The leaf is one of the most suitable designs to paint on stones. Here I used five similar oval shapes to show different possibilities. Using a pencil, draw your leaf sketches on the stones. It's better to use harder 2H pencils because they won't leave lead powder on the stone's surface.

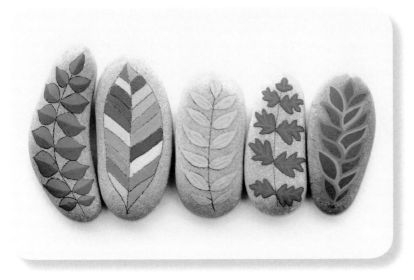

2 Paint your leaves with the colors you like. You can use acrylic paints and inks with thin brushes, or you can work with paint pens.

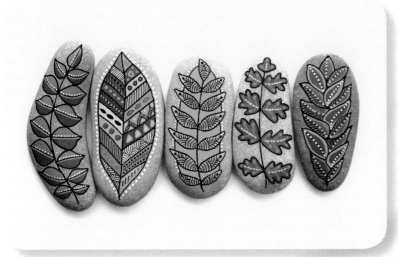

3 Use black fineliner pens to add a contour around the leaves. You can draw parallel lines, half circles, and dots to fill each leaf. Adding some dots with white acrylic ink around the contours or inside the small leaves will create an extra-fine look.

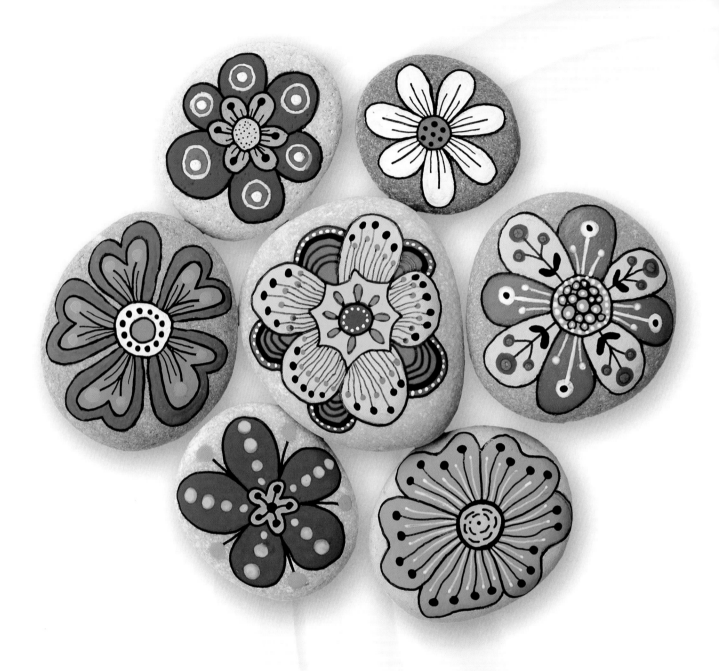

Simple Flowers

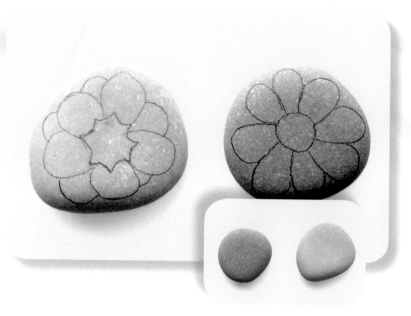

1 You will need some round, flat stones for this project. Draw your flower sketches on the stones with a pencil.

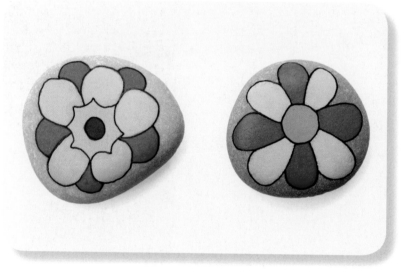

2 Then color the flowers using acrylic inks and size 00 round brushes. After your paint dries completely, use a fineliner pen to outline the edges of the flowers. This will make them more visible.

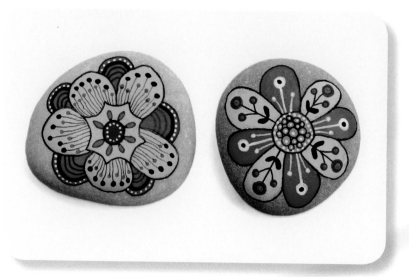

3 Next, add details to your flower designs. Here I used simple lines, drew small plants inside petals, and added dots of different colors. You can use paint pens with extra-fine tips for all these details.

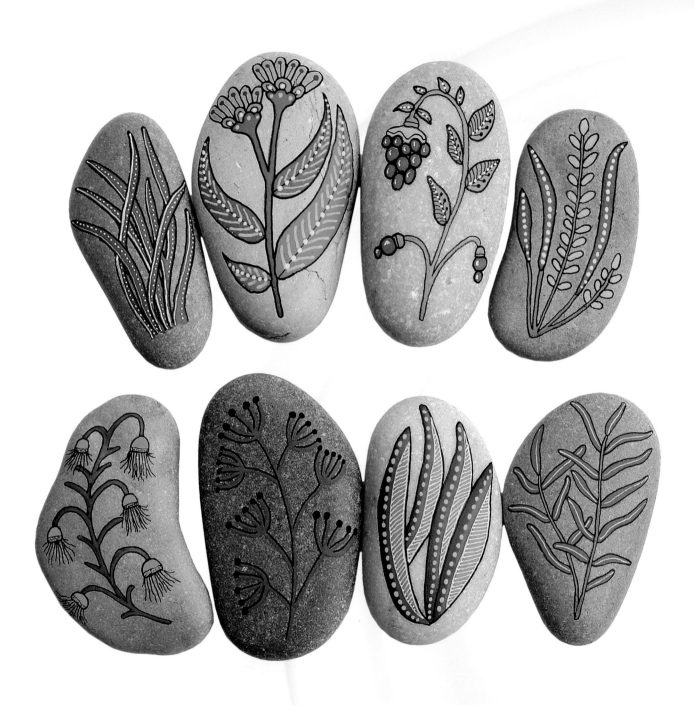

Blooming Botanicals

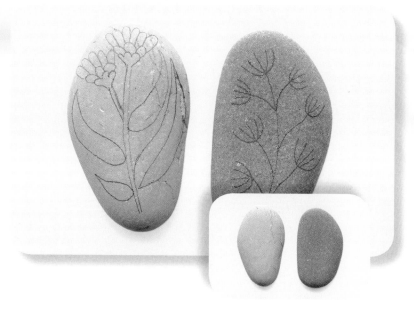

1 You will need some oval-shaped, flat stones for this project. Draw some simple, tiny plants with a pencil. You can use your imagination or you can take inspiration from nature.

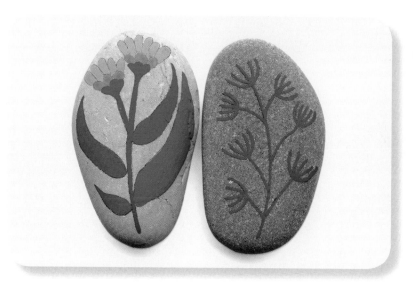

2 Using acrylic inks, dip pens, and paint pens, add color to your designs. For the plants featuring lines only, you can simply trace over the pencil sketch lines with a dip pen or with extra-fine paint pens.

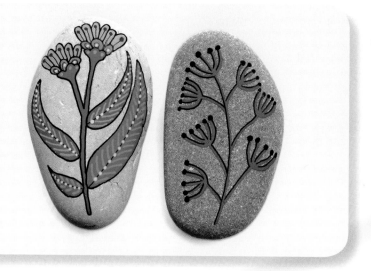

3 Use a black fineliner pen to add contour and shadowing to your plants. Then, to finish your plant designs, add some small details such as dots and thin lines.

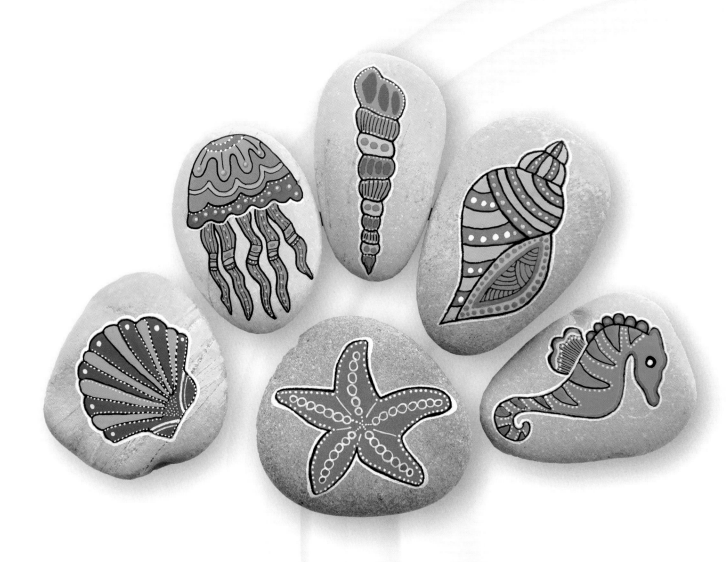

Sea Themes

1 Look for stones of different sizes and shapes and draw sea shells or other sea creatures on them.

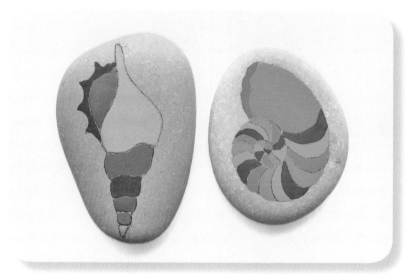

2 Paint your designs with the colors you prefer. Here I used some blue hues and some pastel tones. Use acrylic paints and inks with thin round brushes.

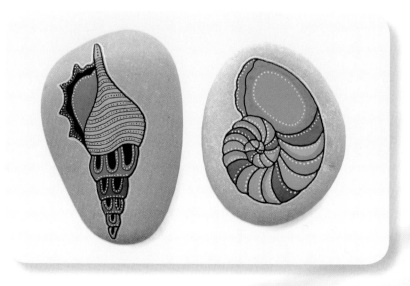

3 Draw a black line around your designs with a black fineliner pen. When you work with small stones and pale colors, it's better to add a contour to the design for a sharp look. Finish your designs by adding some fine details. You can add black or white dots near black lines, or you can fill empty spaces with some semi-oval shapes filled with black paint and some parallel fine lines.

29

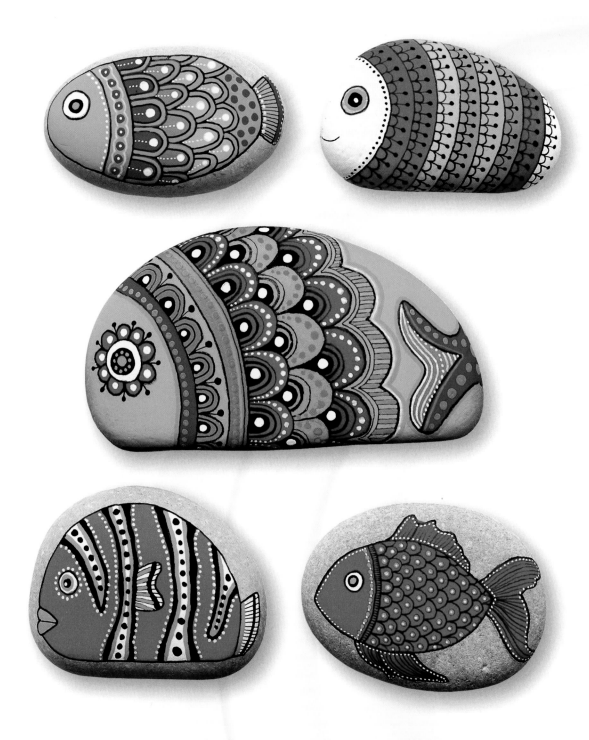

Friendly Fish

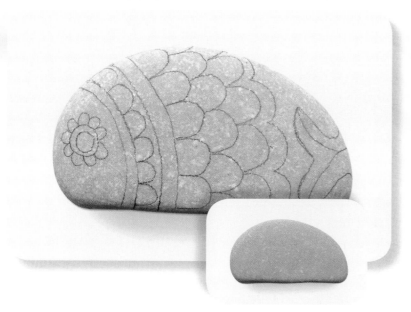

1. In this project you can use oval-shaped and semi-round stones. As always, draw your fish sketch on the stone using a pencil.

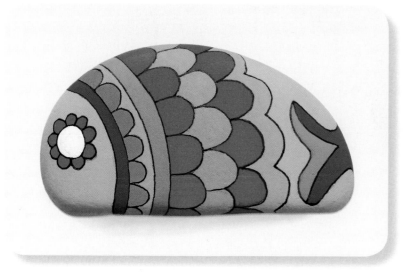

2. With different bright colors, paint your design. Then, using a black fineliner pen, add contours to all designs.

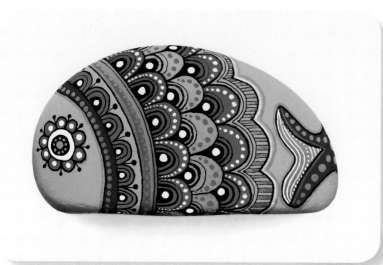

3. Now you can start to add final details to your fish. Using black and white fineliners, add some details on the eyes, scales, and tail. Try some bold dots in different colors to make your fish more vibrant.

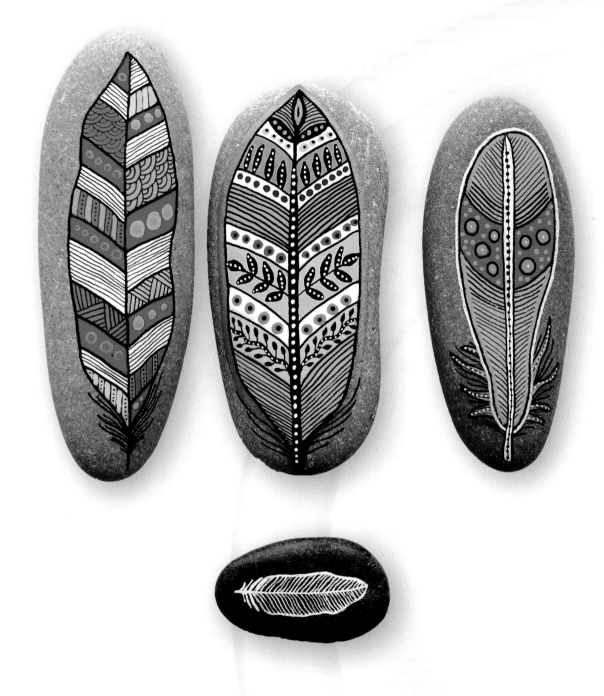

Elegant Feathers

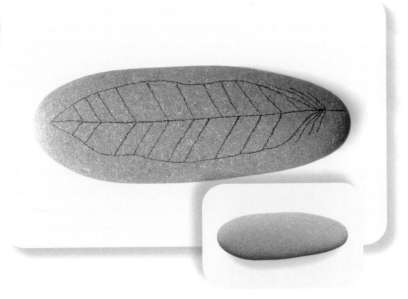

1. In this project you can use oval stones, tall stones, or little pebbles. As always, draw your feather sketch on each stone using a pencil.

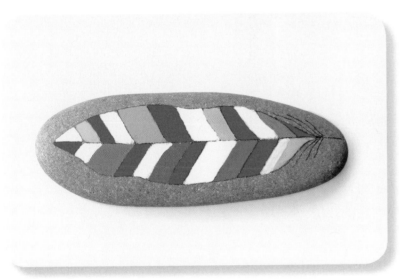

2. Then with different bright colors, paint your design. Actual bird feathers are beautiful objects that come in many different colors, so why not try a lot of different colors in your designs, too?

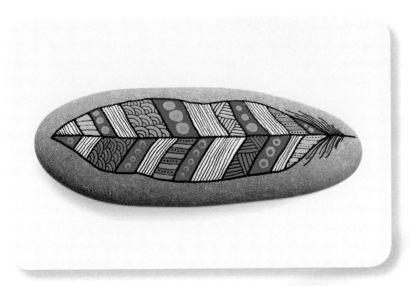

3. Using a black fineliner pen, add contours to your designs. Then you can add details. Try parallel thin lines, small and large dots of different colors, and parallel semicircles. (Try using white ink and dip pens to create a monochrome look on darker pebbles.)

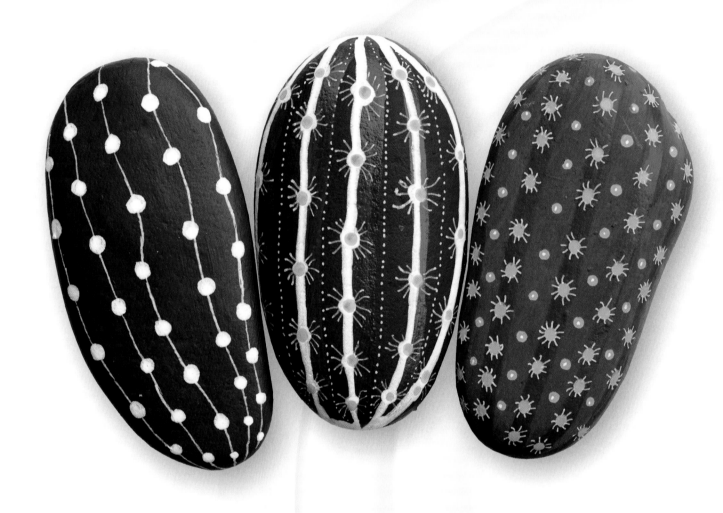

Cool Cacti

1 For this project, you will need some oval-shaped stones. Here I used three stones of a similar shape and height. You can also use stones with bigger or smaller dimensions.

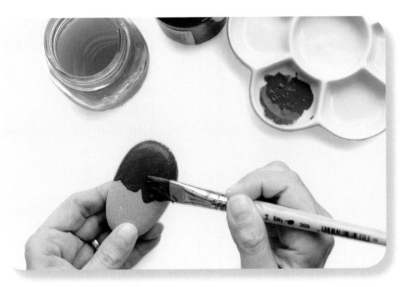

2 Once you choose your stones, you can start to paint them with acrylic paint. Using different tones of green will create a better look for your cacti designs.

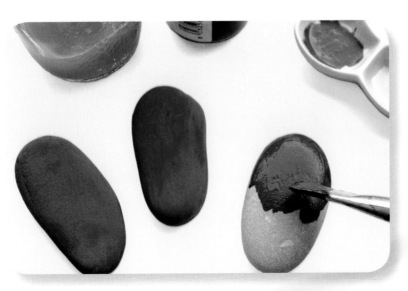

3 Make sure the paint covers all parts of the stone, because these should have a three-dimensional look when finished. If you add different layers of paint, let each layer dry for at least one hour.

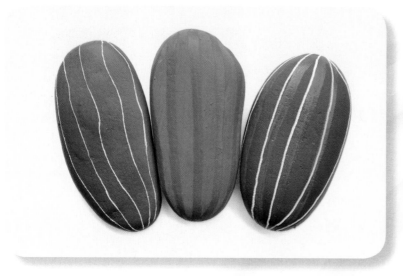

4 After your stones have completely dried, you can paint some vertical lines on them to prepare a base for the cactus design. These lines can be made with darker green acrylic paint, or white acrylic ink with a dip pen.

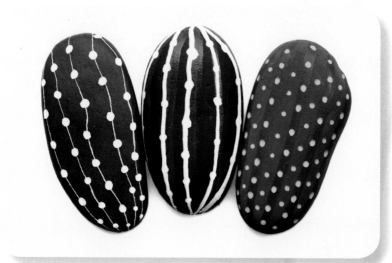

5 In this phase you can start to shape your cactus design. Make some white dots where you drew vertical white lines. You can make thicker lines and dots to add diversity to your cactus designs. Try some yellow dots with paint pens directly on the stone's green background along the darker green lines.

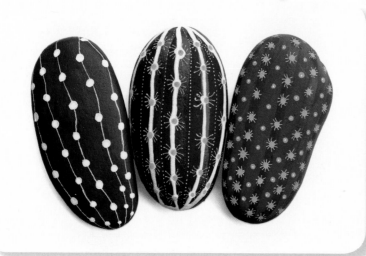

6 Add more detail to your cactus designs, such as small white dots on yellow dots. Add thin white lines around the white and yellow dots to stylize the spines of your cacti. You can also leave some white dots without spines to create diversity between them.

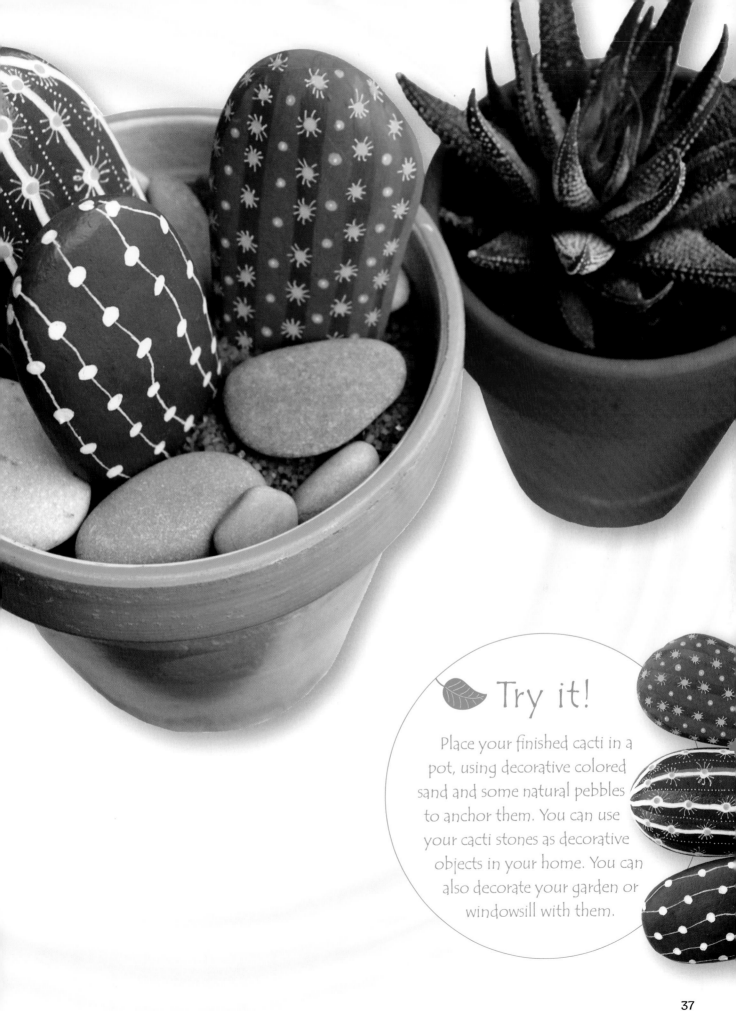

Try it!

Place your finished cacti in a pot, using decorative colored sand and some natural pebbles to anchor them. You can use your cacti stones as decorative objects in your home. You can also decorate your garden or windowsill with them.

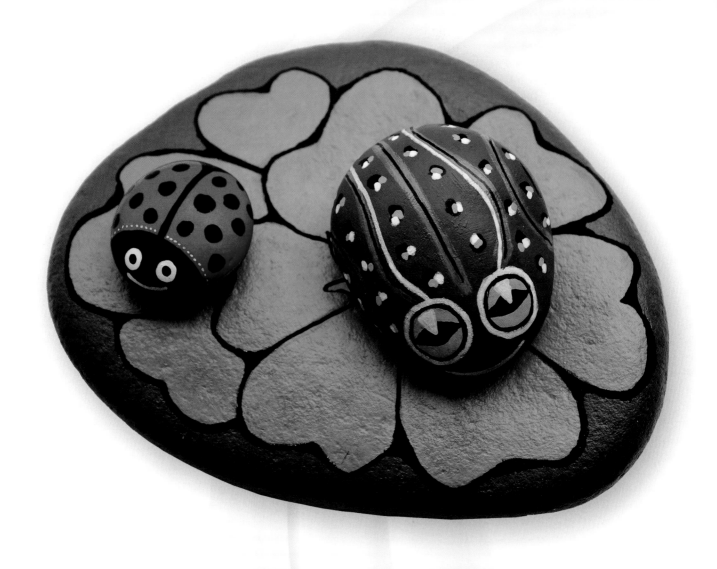

A Frog's Pad

1 For this project you will need stones of different sizes and shapes. For the frog it is fine to find a stone similar to the shape of a real frog, with a flat base and oval shape. Smaller round or oval pebbles are fine for the ladybugs. You will need a large, flat stone for the lily pad. Make sure the dimensions of the lily pad stone are large enough to allow the frog and ladybug stones to fit comfortably on it.

2 Using acrylic paint and a brush, paint the lily pad and frog stones with different shades of green. For the ladybug pebble, use red acrylic paint.

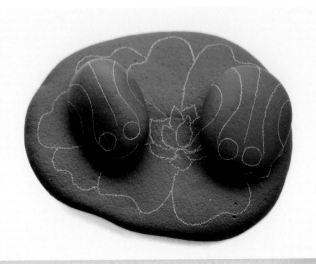

3 Draw your basic sketches for the frog, lily pad, and ladybug. Draw the frog's eyes, and the main lines that will define its body and legs. Draw the flower and the petals of the lily pad. Use a white pencil to sketch finely. For the ladybug, draw the body parts with a pencil.

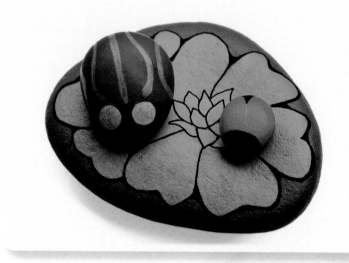

4 Using a lighter tone of green, paint over the white lines of the frog. For the eyes, you can use white or yellow acrylic paint. For the lily pad stone, use pink for the flower and lighter greens for the petals. Next, using black acrylic paint and a thin round brush, add some contour to the petals and the flower of the lily pad stone. Paint the head and back parts of the ladybug with black acrylic paint.

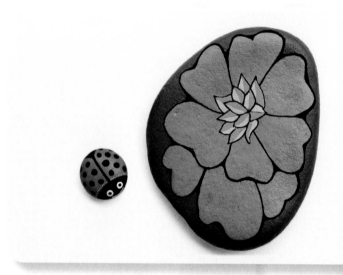

5 Now you can add some detail. For the lily pad, try different shades of pink for the flower's petals, separating each petal down the middle. For the ladybug, add bold black dots to the body and two white dots for eyes. You can add a mouth line with white ink and a dip pen, and add some small white dots between the head and wings.

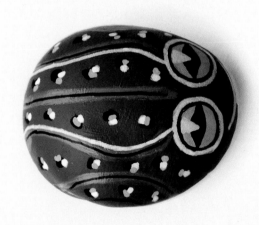

6 For the frog, add some parallel white and black lines to the lighter green lines you made previously. Then make some irregular dots in black, yellow, and white. Add detail around the eyes, first with a black fineliner pen, then with white. Inside the eyes, use black and white colors to create an appearance of a reflection of light.

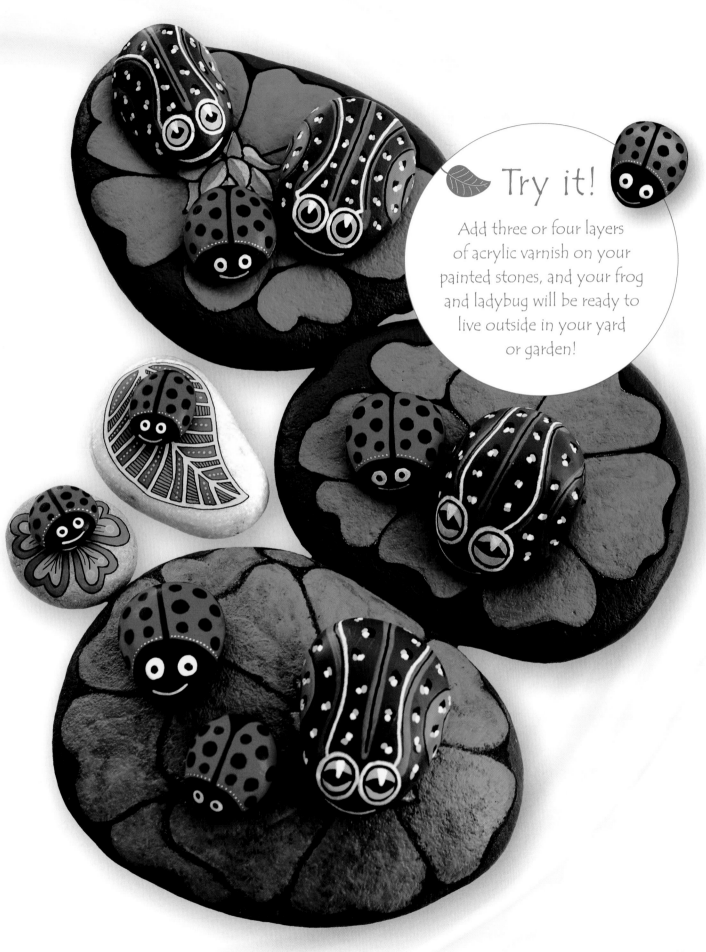

Try it!

Add three or four layers of acrylic varnish on your painted stones, and your frog and ladybug will be ready to live outside in your yard or garden!

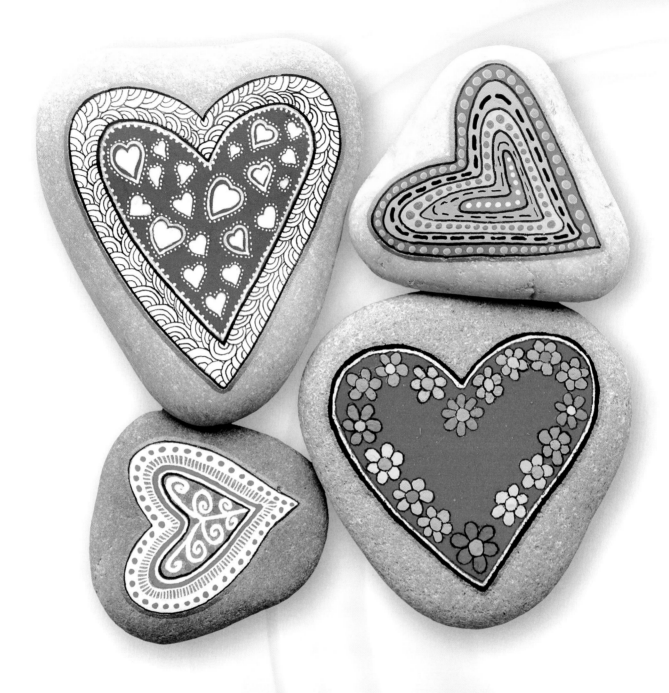

Cheerful Hearts

1 Hearts are simple but beautiful designs to paint on stones. You will need some heart-shaped or some triangle-shaped stones for this project.

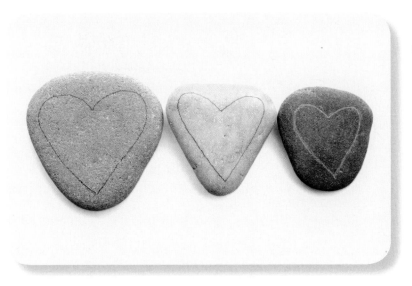

2 Start by simply drawing your heart sketch on the stone; use a pencil for lighter stones and a white pencil for darker stones.

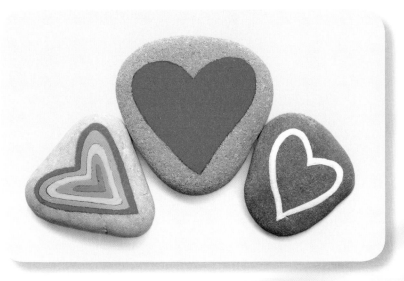

3 I included three different styles here to show you some different heart stones you can create. You can use red acrylic paint inside your heart, you can paint bold concentric lines with different colors, or you can define your heart design with bold white paint.

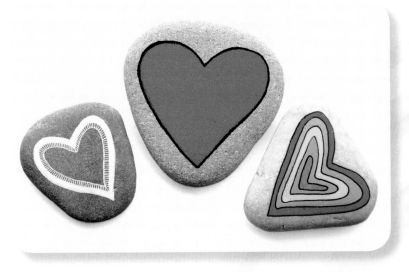

4 Add contour with a black or white fineliner to give a more stylish look. Add some thin lines to the darker heart pebble with white ink and a dip pen to complete its border.

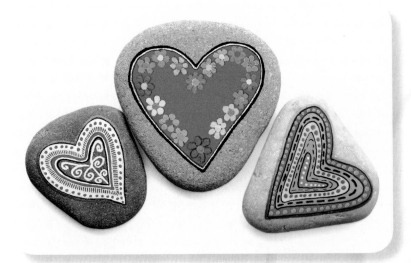

5 Add some details to your heart stones using different-colored paint pens. Here I added colorful, small flowers inside the red heart and drew a black outline on them. As a final touch, try adding another contour with gold acrylic ink and a dip pen.

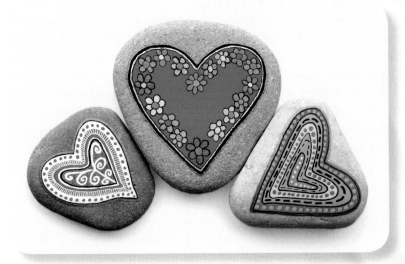

6 For other colorful hearts, you can add different dots and lines with different colors, using paint pens and fineliner pens. For the dark pebble with white heart you can add some floral lines and some red dots for a better look.

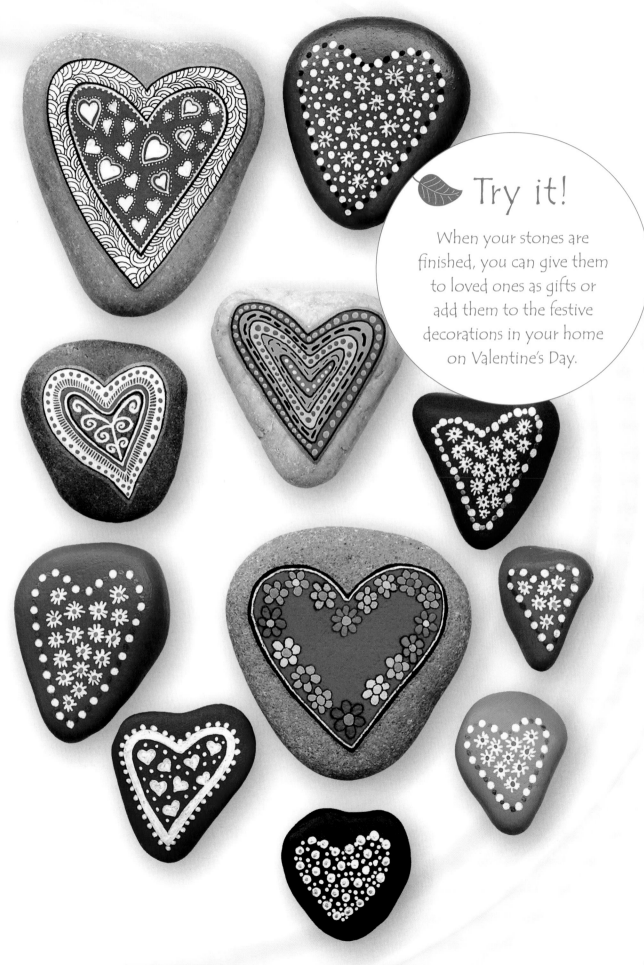

Try it!

When your stones are finished, you can give them to loved ones as gifts or add them to the festive decorations in your home on Valentine's Day.

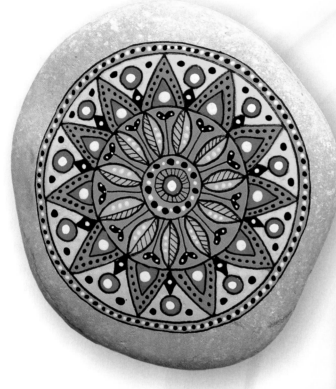
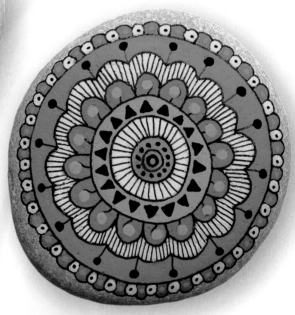

Simple Mandalas

1 For painting a mandala you will need a round, flat stone. Look for stones with a smooth surface. Then you can sketch your mandala design on them. Start with a simple circle, always at the center. After some concentric circles, you can add some petal-like semi circles and another border around them. You can finish your sketch with another large circle and with small and large dots around it.

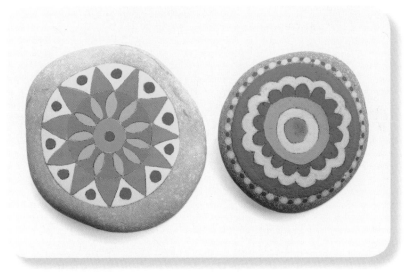

2 With acrylic colors and inks, fill all the parts of your mandala. I chose yellow and green for one, and multiple colors for the other. The possibilities are endless.

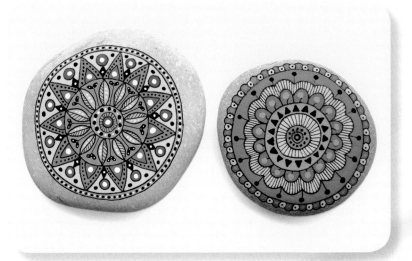

3 Draw contour lines around the painted parts with a black fineliner pen. Then add details to your mandala stone with some black dots around the center circle; then add some small black triangles inside the other circle. Add lighter-colored dots inside the semicircles. Continue to fill your mandala with parallel thin lines and some small and large dots.

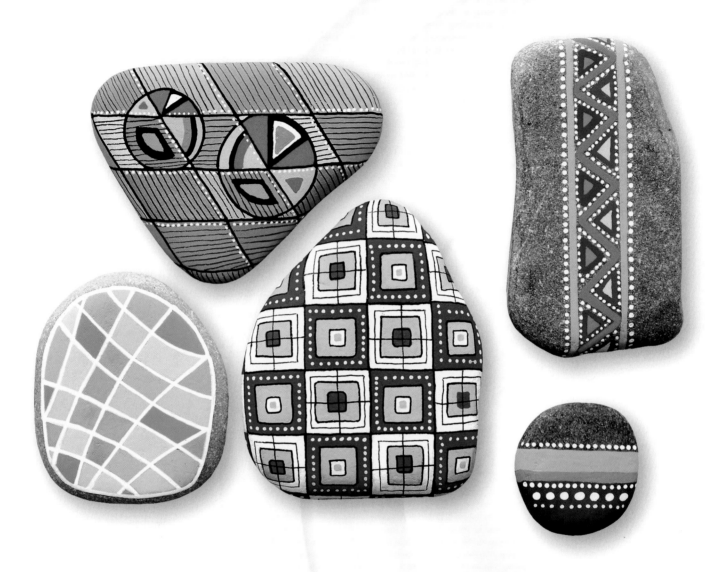

Geometric Art

1 Lines, circles, and squares are the most common elements to use when decorating your stones. In this project you can use all geometric elements freely. It's fun and simple. You can use different-shaped stones.

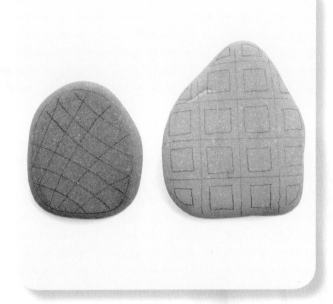

2 Draw your sketch on the stone with a pencil, and add some parallel lines and some circles between them. You can work with lines, circles, squares, or a combination of geometric shapes.

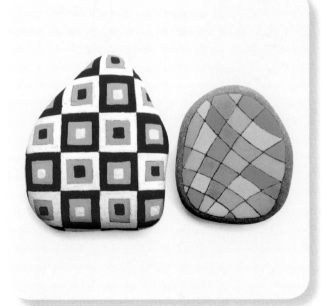

3 Fill every divided part of your design with different acrylic colors for a brilliant look. Adding an outline to all parts with black or white will make your design even more vivid.

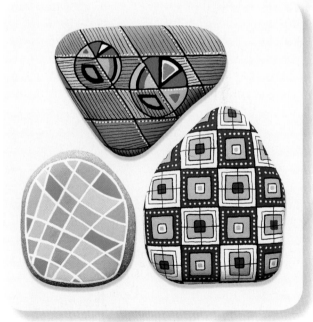

4 Next, vary your designs with fine parallel lines, some concentric triangles with different colors, or white dots. Use paint pens and fineliner pens to detail your designs.

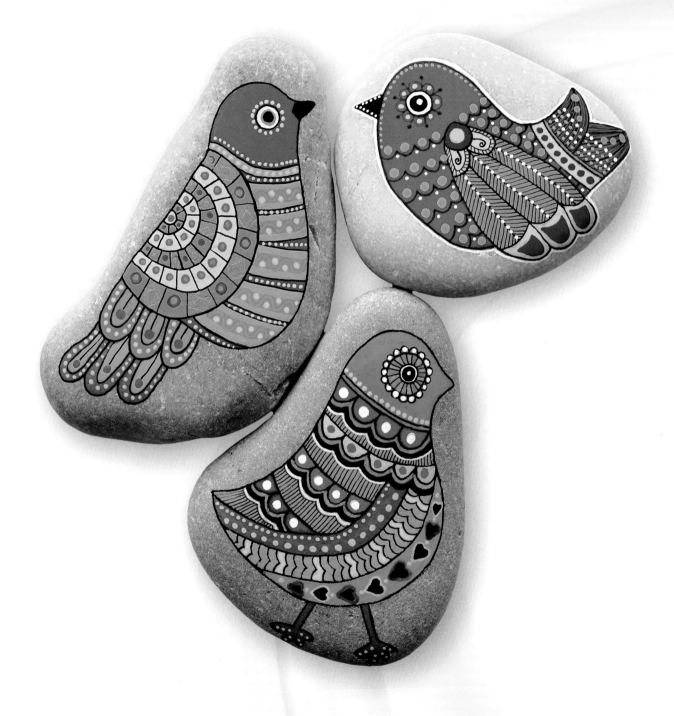

Simple Birds

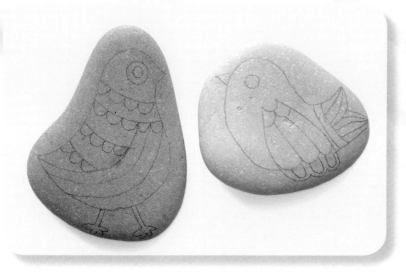

1 Look for a stone that suits a bird shape and sketch your bird design using a pencil. Draw some concentric semicircles for the wings.

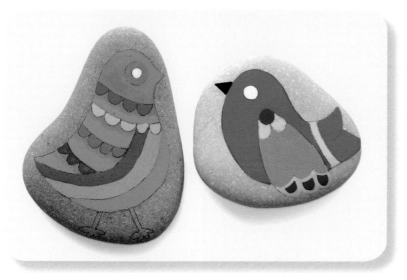

2 Choose colors you want to fill your bird's main parts with. Use different colors for a stylish look.

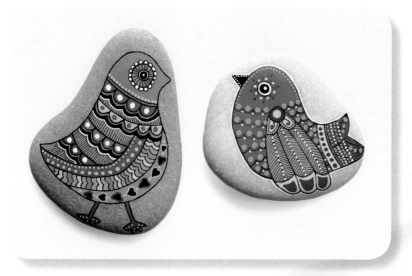

3 Add black line contours with a fineliner pen. Next, to add simple details to your bird design, divide the body of the bird with lines and fill them with wavy lines and dots. Divide the wing's parts into semicircles, and fill them with large dots and squares. For the tail feathers, use vertical lines and large dots at the end of the tail. For a final touch, add some small dots to the tail, eye, and neck of the bird.

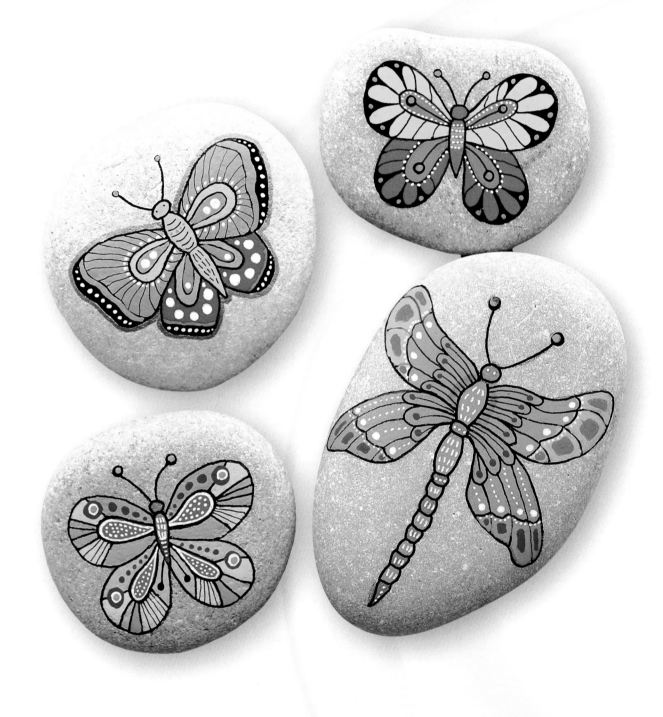

Simple Butterflies & Dragonflies

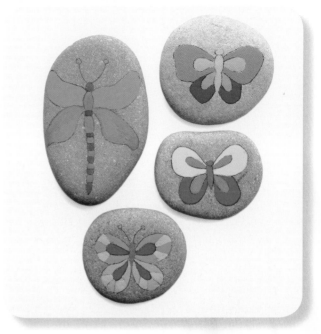

1 For this project you will need two different kinds of stones. For the butterfly, some round or oval-shaped stones will be fine. For the dragonfly, you must look for some tall triangle or oval stones.

2 Draw your sketches of butterflies and dragonflies on your stones using a pencil. Now you can start to paint your stones. Using different vivid acrylic colors, fill all your designs.

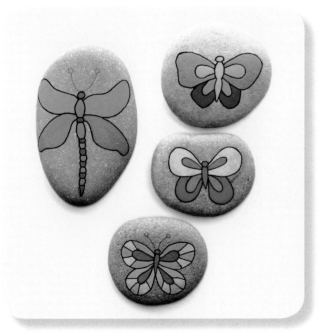

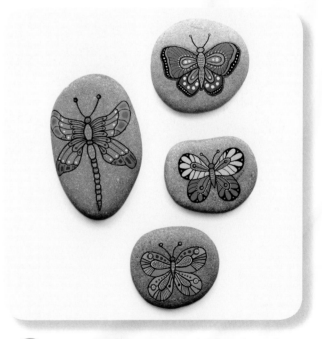

3 Then add a contour line to them with a fineliner pen.

4 You can add some simple details with black fineliners, colored paint pens, or acrylic inks with dip pens in this step. I used lines and dots in different sizes, some different color patches, and tiny, short white lines to give them a better look.

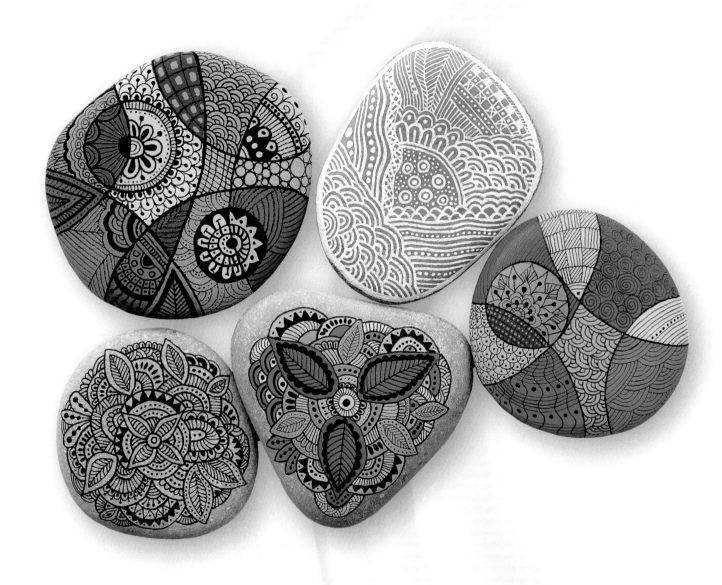

Structured Doodles

1 Making some structured doodles on stones is always fun. The shape of the stone is not so important for this project; you can look for all kinds of smooth stones. Here I used a triangle-shaped stone.

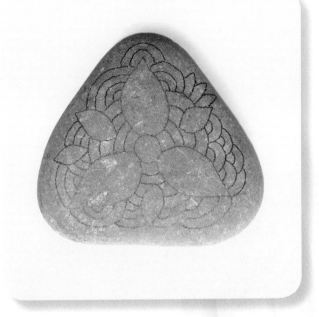

2 Start by sketching on your stone's natural surface with a pencil; use your imagination to create different motifs.

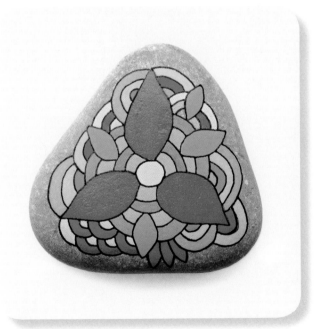

3 Then, using paint pens or acrylic inks, add color to your designs. Add some contour lines as well.

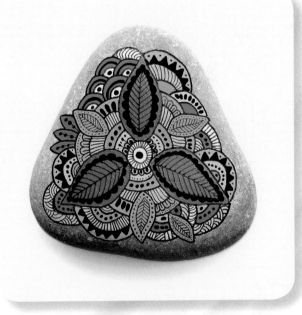

4 To finish your mosaic design, add details with a black fineliner pen. As always, you can use lines, dots, triangles, leaves, semicircles, wavy lines, and more to fill your design. More details will give a richer look to your design.

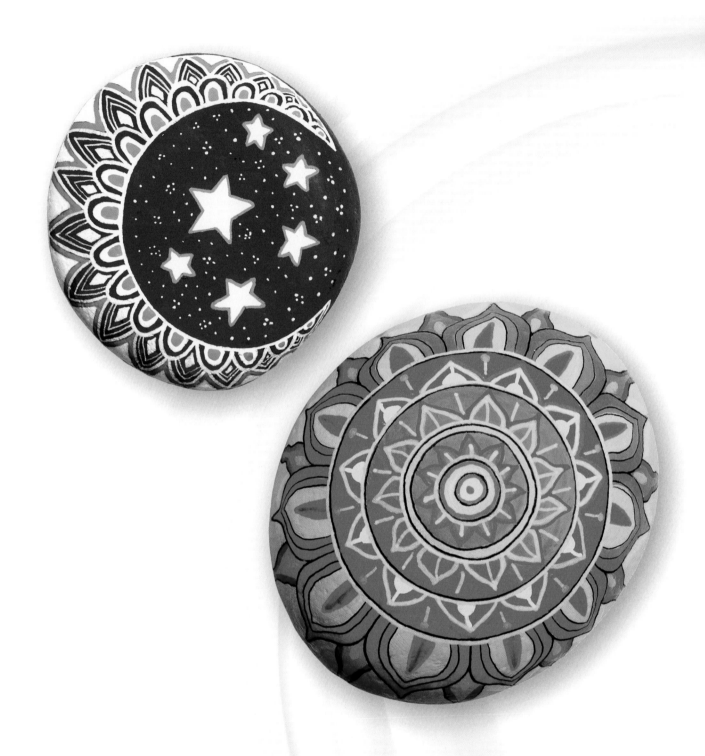

Sun Stone, Moon Stone

1 For this project, you will need two large, round stones.

2 Paint the surfaces of both stones—yellow for the sun design and dark blue/cobalt for the moon design. Wait one or two hours to make sure the paint has completely dried.

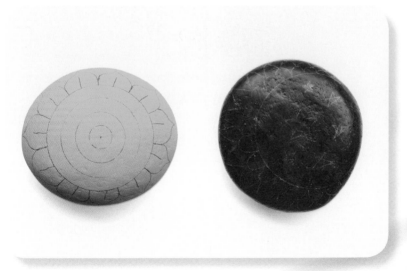

3 Start to draw your designs on the stones with a lead pencil (sun stone) and with a white colored pencil (moon stone). Add concentric circles and some petal-like shapes as stylized rays to the sun design, and some small stars to the moon design.

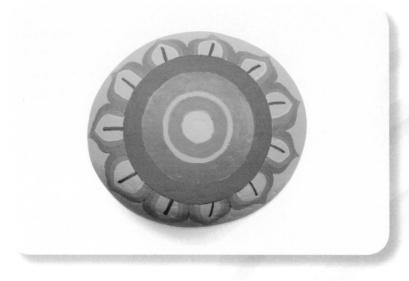

4a For the sun stone, using red and orange hues, fill the concentric circles with acrylic paint or ink. Then pass over the rays of the sun with bold colored lines, always with red and orange acrylic colors or inks.

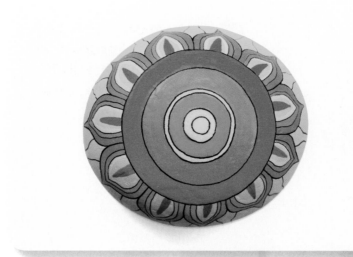

5a After you have allowed time for the paint to dry, add some contour lines to the concentric circles and sun's rays with a black fineliner pen.

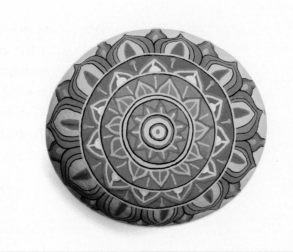

6a Now add more details to your sun design, drawing some extra triangles for rays with orange and red paint pens, and some yellow lines inside the triangles. Add some fine dots and lines between the triangles, too.

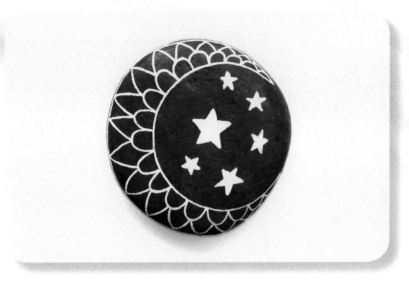

4b For the moon design, pass over the sketch lines with a dip pen and white acrylic ink. Fill the small stars and the outside border of the stone with white acrylic ink, too.

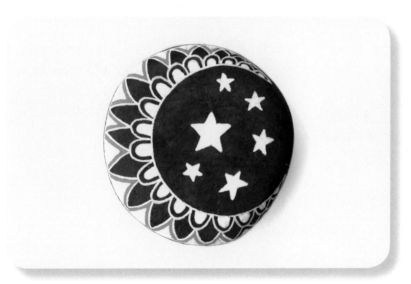

5b Next, add some details such as light blue lines around the outside of the triangles, and fill the semi-oval parts with white paint.

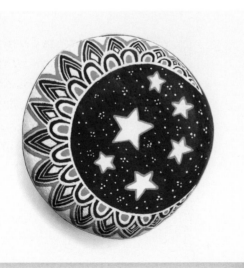

6b For more detail, add some light blue contours to the stars and also over the white parts inside the semi-ovals. Add some thin white lines with a dip pen to the triangles. For a final stylish touch, add tiny dots in white to represent a starry sky.

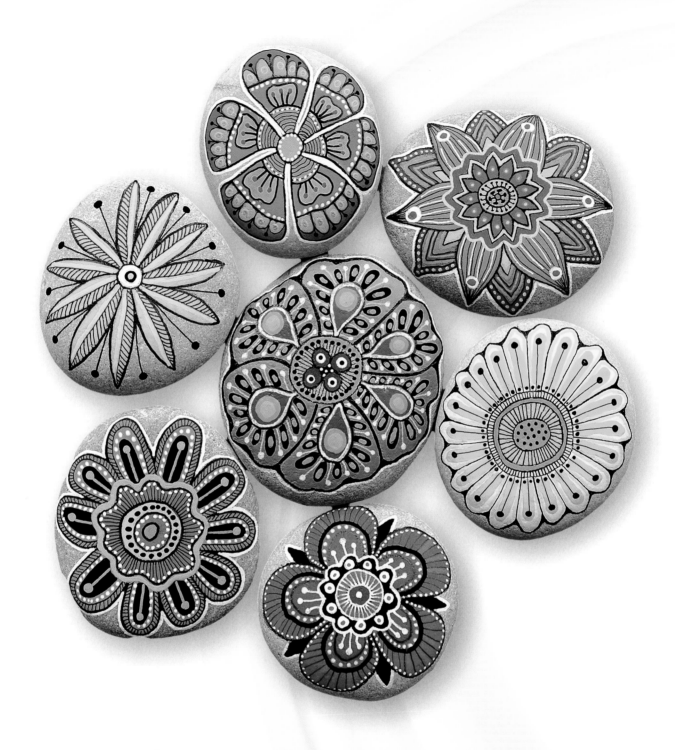

Detailed Flowers

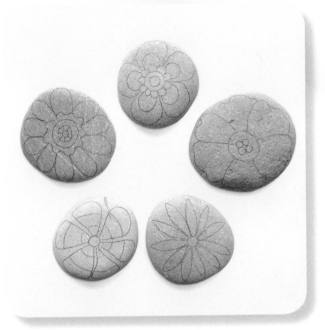

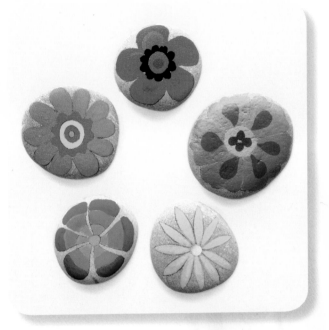

1. For this project, as with the Simple Flowers, you will need round, flat stones. Once you find some, draw your flower sketches directly on the natural surface.

2. Start to paint your flowers. If you chose large stones, you can work with acrylic paint and thin brushes. If your flower desings are on smaller stones, you can work with paint pens with extra-fine tips directly.

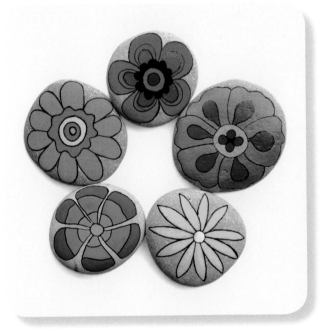

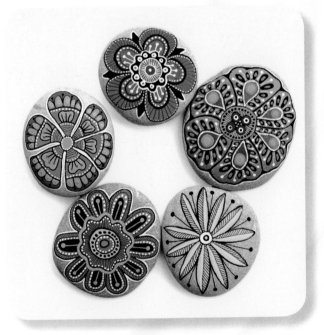

3. With a black fineliner pen, pass over the contour lines of your flower designs. Next you can start to work on the details.

4. You can fill your flower designs with as many details as your imagination can provide, such as thin diagonal lines, rows of small petal shapes, paisley and teardrop motifs, small dots over large dots, and so on. Using different-colored paint pens will help your flower stones have a colorful, vivid look.

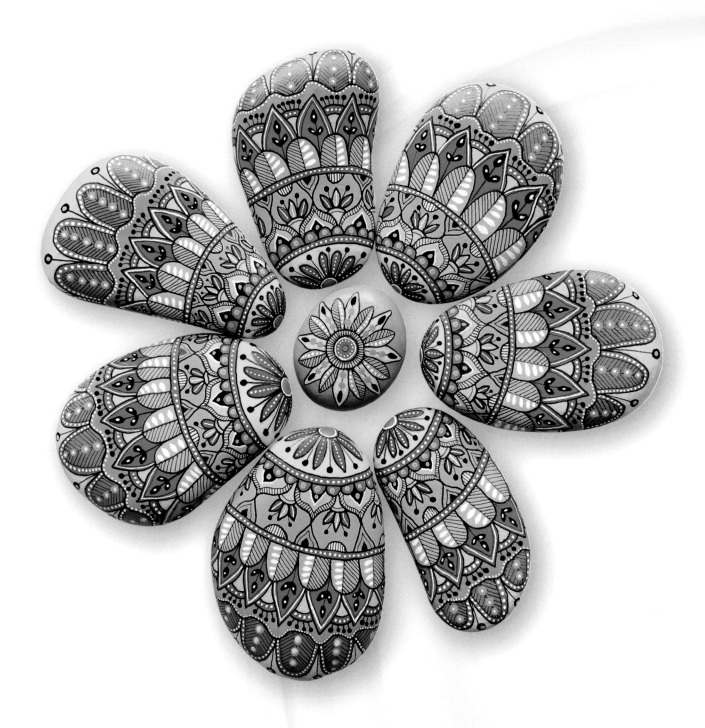

Multi-Stone Mandala

1 For this project you will need seven similar-shaped stones to use together. Leaf-shaped stones are ideal. Put all your stones together in the form of a flower.

2 Next, start your sketch. Start with some concentric circles. Fill the center of your stones with small half-flowers. Then fill the area between two circles with floral motifs such as semi-petal rows, half-flowers between them, triangle rows, and so on.

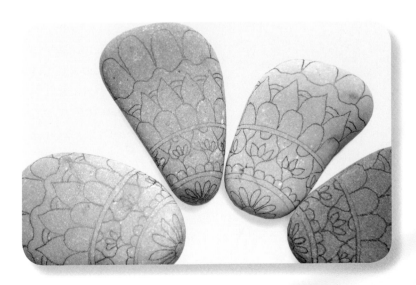

3 Then fill the rest of the empty spaces of the stones with semi-ovals and triangle rows.

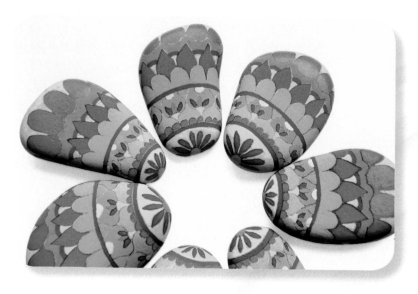

4 Start to paint your flower petals with different colors using acrylic paint or ink with thin brushes.

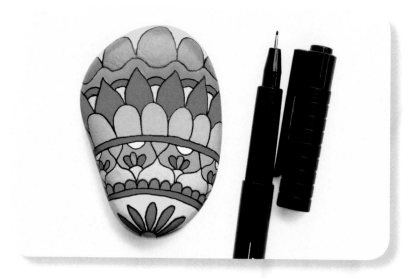

5 Then using a black fineliner pen, draw your bold contour lines. Next, you can start to fill your petal stones with details.

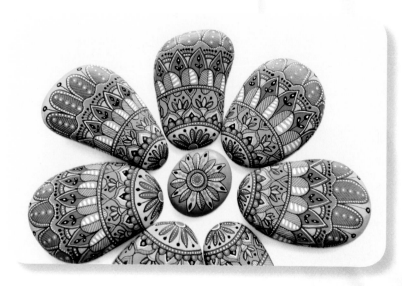

6 As you see in the picture, try to use simple lines and dots. Divide the small petal-like parts with lines, then use simple plant motifs or large dots to fill the inside. Use extra-fine-tip paint pens, dip pens with acrylic inks, and very thin fineliner pens to do this work. It depends on you how much detail you want to see on your stones; use your imagination to create variations of details.

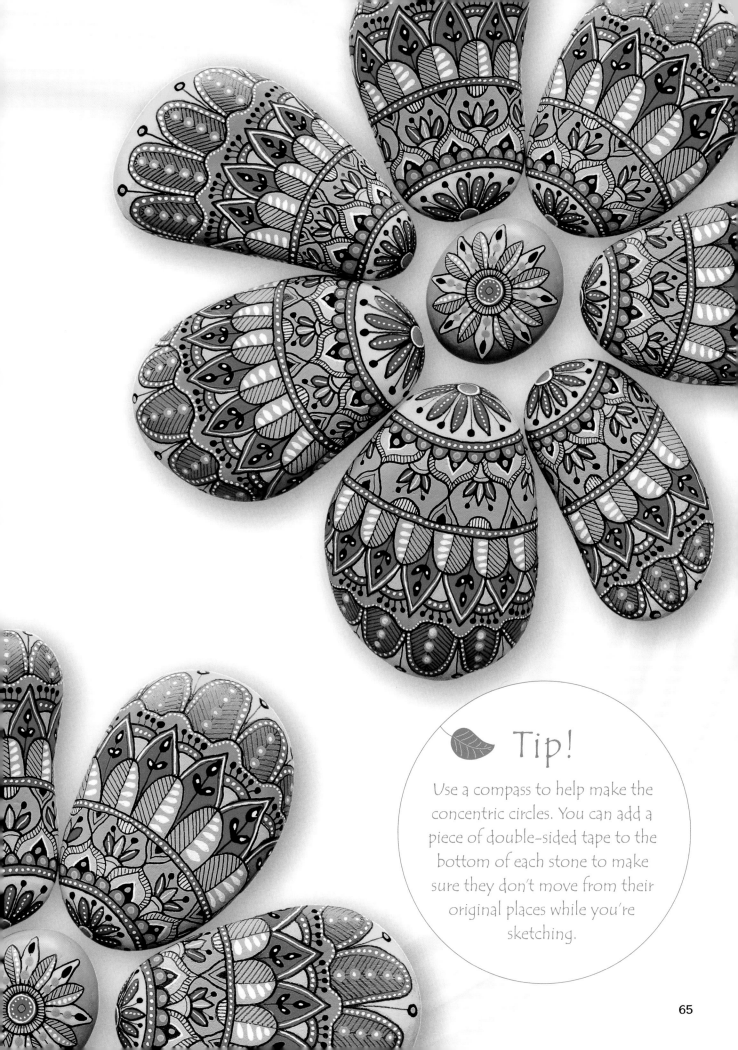

🍃 Tip!

Use a compass to help make the concentric circles. You can add a piece of double-sided tape to the bottom of each stone to make sure they don't move from their original places while you're sketching.

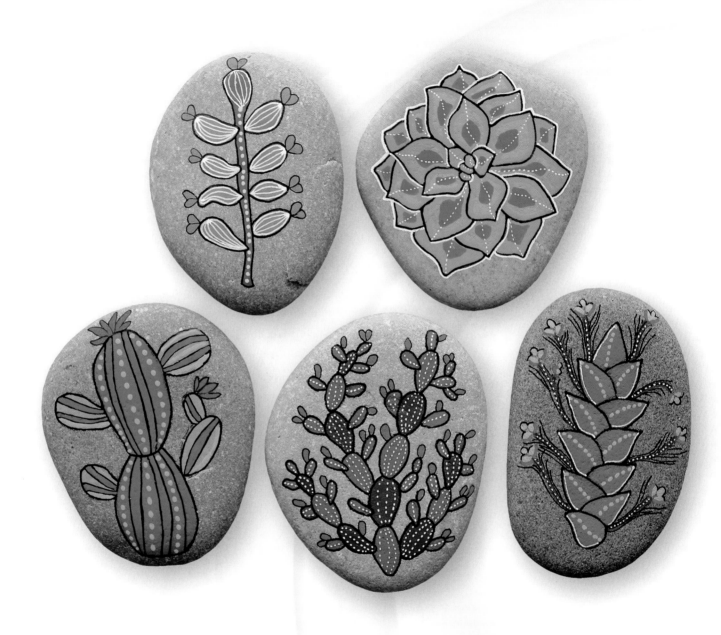

Succulents

1 Look for small, flat stones with different shapes, such as round or oval, and draw your succulent sketches on them using a pencil.

2 Then, choose the acrylic colors you want to use. Here, I chose natural-looking colors like green and turquoise. Fill the parts of your design using different hues of green to give movement to your succulents. Then add contour lines using a black fineliner pen.

3 For a final look, add details to your designs. You can add lines and dots to cacti for a spiny look; you can even add red/pink flowers to them. Add some flower-like details to other succulent designs with a pink paint pen, or a black fineliner pen. With some green patches and tiny white dots, finish your turquoise succulent design.

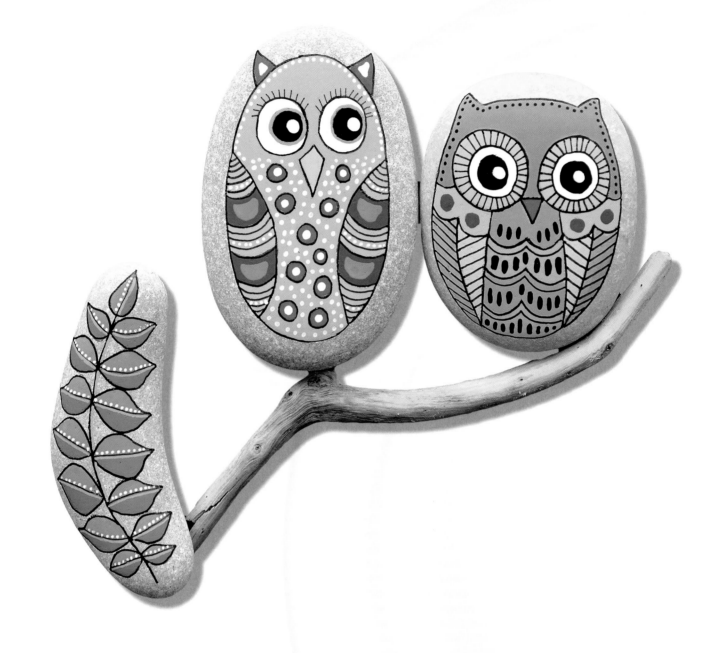

Simple Owls

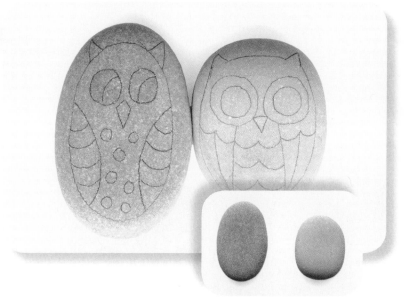

1 Look for a stone that suits an owl shape (most oval stones are fine) and sketch your owl design using a pencil. Draw some parts of the body, wings, eyes, and the beak.

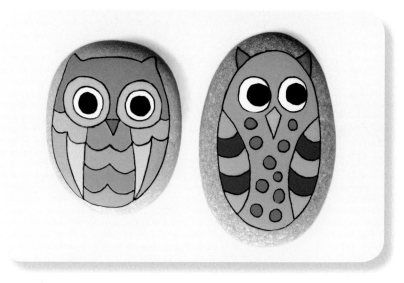

2 Choose the colors you'd like to use for your owl's main parts. Use different bright colors for a stylish look. Then add black contour lines with a liner pen.

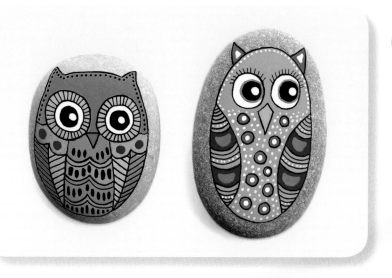

3 For a simple owl design, divide the body with wavy lines and fill the spaces between them with tiny ovals. Or, you can add large dots only, then with another color you can place smaller dots over them. Add diagonal lines across the wing sections for stylized feathers. Or, you can draw a few curved lines and add another color to the wing's empty parts. For a final touch, add some white dots to the eyes.

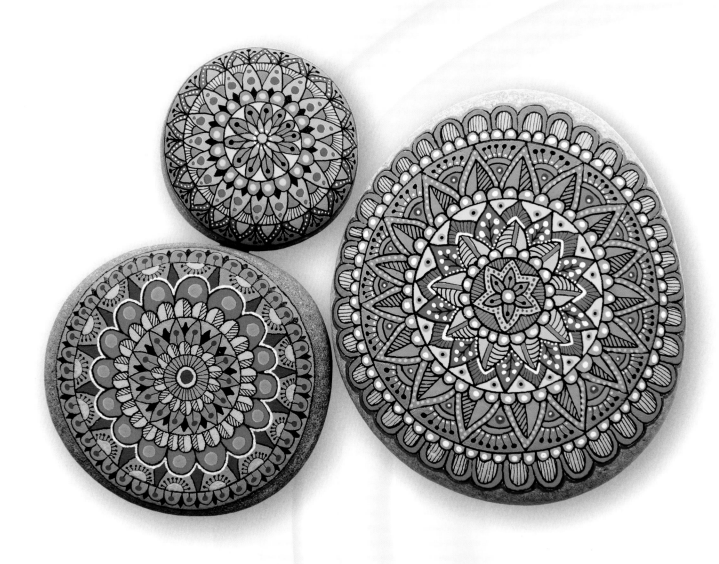

Detailed Mandalas

1 For painting colorful, detailed mandalas you will need some round, flat stones. Look for stones with a smooth surface. Then you can sketch your mandala designs on them.

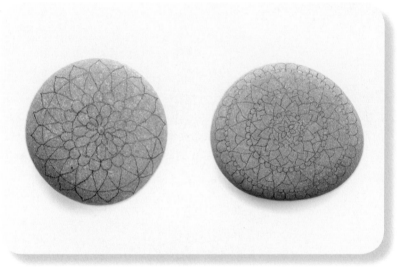

2 Start with a simple circle, always at the center. After adding some flower and semi-petal motifs, draw a circle around them. Try adding some semi-ovals in a row, and then some triangles around them. Next, draw another circle around the tips of the triangles and add semi-petal motifs above. You can also draw a variety of motifs on a row of small circles, as you see on the right-hand stone.

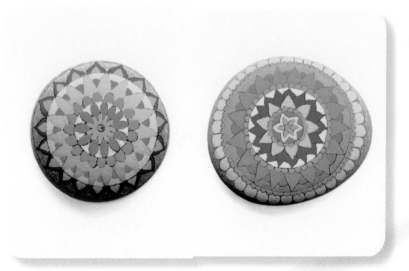

3 Fill all the parts of your mandala with acrylic colors and inks. Here I chose some different pastel colors, but the possibilities are endless.

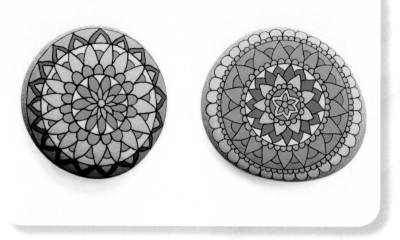

4 Draw contour lines with a black fineliner pen. After the ink dries, you can start to add detail to your mandala stones.

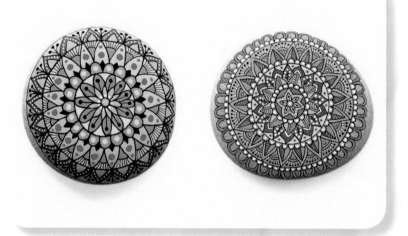

5 Start with some black dots and lines, and insert some small black triangles between semi-oval motifs. Add lighter-colored dots inside semi-ovals. Continue to fill your mandala with parallel thin lines and some small and large dots. Use paint pens, dip pens with black ink, and black fineliner pens for these details.

6 With this technique you can create different mandala designs on your stones, changing colors and shapes. The more designs you try, the more confident you will become. Make sure you have all your acrylic colors, paint pens, and fineliners ready at your workstation!

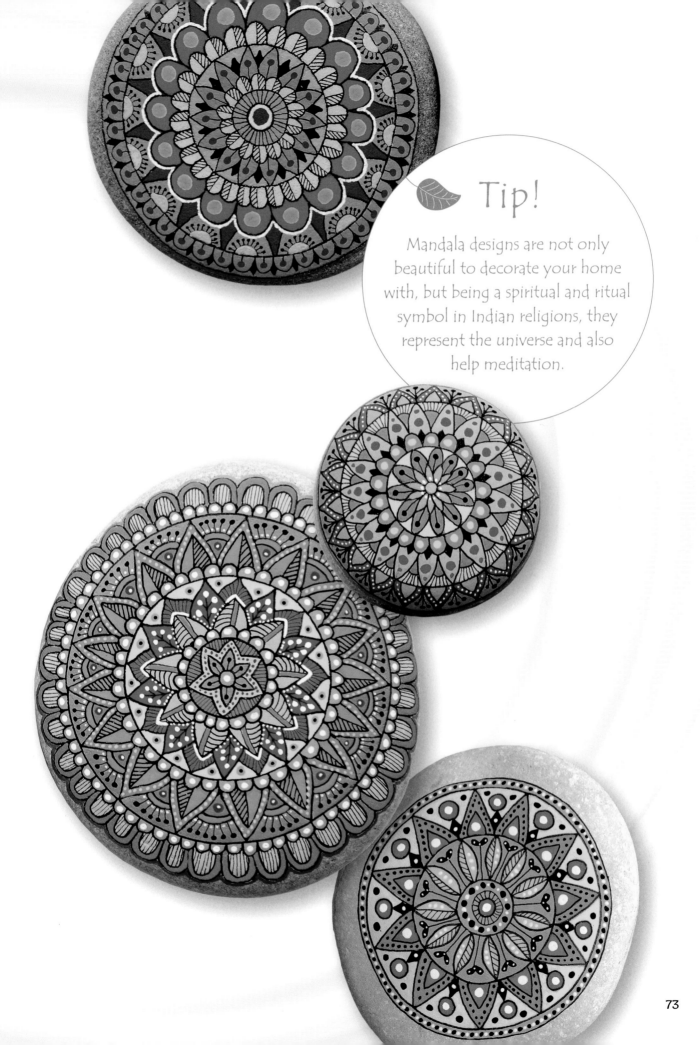

🍃 Tip!

Mandala designs are not only beautiful to decorate your home with, but being a spiritual and ritual symbol in Indian religions, they represent the universe and also help meditation.

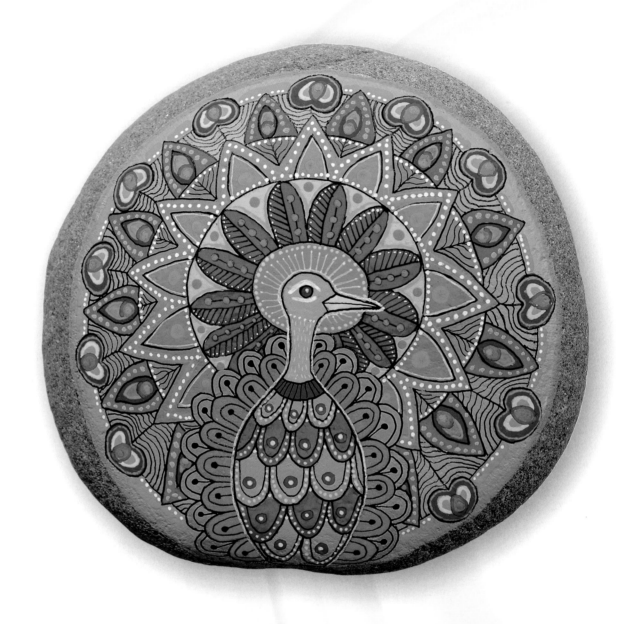

Colorful Peacock

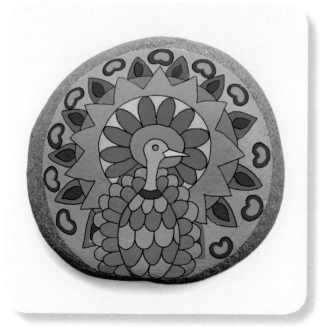

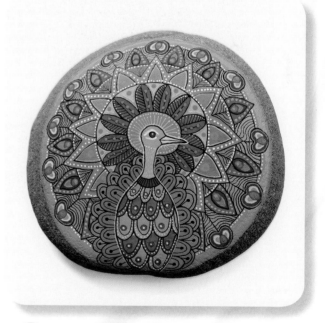

1 You will need a large, round, flat stone for painting a peacock. Paint your stone with a teal or light green acrylic paint, leaving a quarter-inch space at the edges of the stone. This is optional; you can paint the surface all the way to the edges if you choose.

2 After the paint completely dries, make your peacock sketch on the stone with a pencil. Draw the body, and add some circles around it. Then fill the empty spaces between circles as you would a mandala, with semi-ovals, triangles, and feather-like elements.

3 Add colors to your peacock design using acrylic paints and inks of different colors. Next, draw contours for each part of the design with a fineliner pen to give some accent to your colors. Now you can start to draw and paint the details.

4 For the body, add feather-like semi-ovals and fill them with thin lines and dots. Make some dots in the center of the semi-ovals. Add eye details and some tiny white lines to the neck. Then for the stylized feathers, use tiny parallel lines and colored dots to fill the empty spaces. Add contours using different colors.

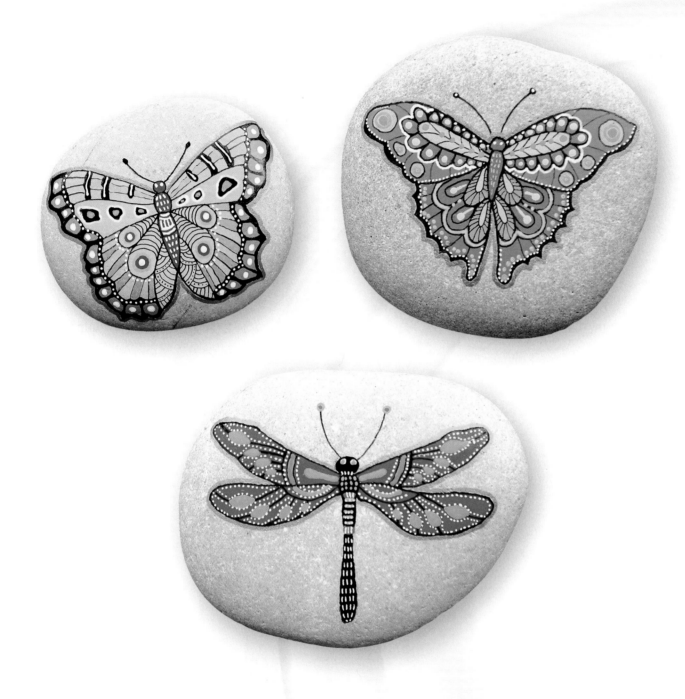

Detailed Butterflies & Dragonflies

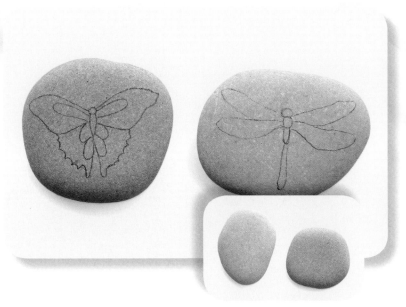

1. For this project you will need some different stone shapes. For the butterflies, some round or oval-shaped stones will be fine. For the dragonfly design you have to look for some oval (but a little tall) stones to fit the design. Once you find the right stones, draw your sketches of buterflies and dragonflies on them with a pencil.

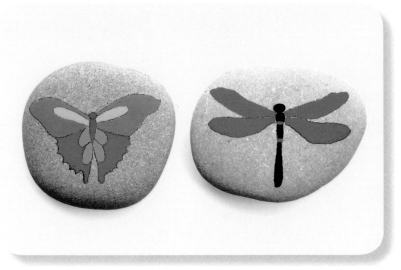

2. Now you can start to paint your stones. Using different vivid colors fill all your designs. Here, I used green and yellow for the butterfly and red and black for the dragonfly. I used acrylic paint and inks.

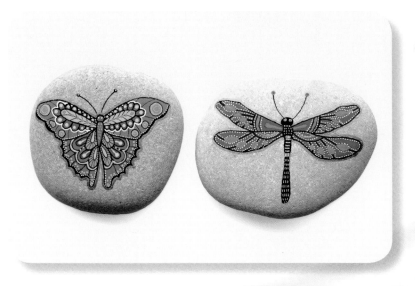

3. Add contour lines to them using black fineliner pens. Next, you can add some details with black fineliner pens, colored paint pens, or acrylic inks with dip pens. I used lines and dots in different sizes and colors, some different color sections, and tiny, short white lines. Adding a gold or bronze border to your design using dip pens and gold or bronze acrylic ink can make your designs more stylish.

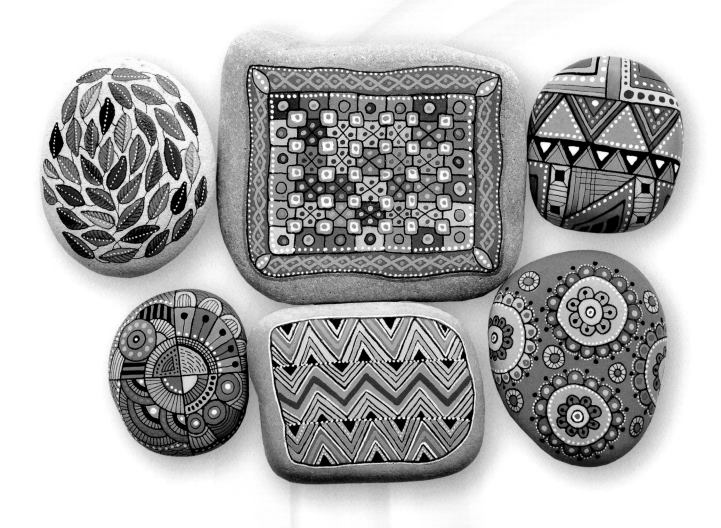

Folk Abstracts

1 You will need some rectangular, round, or oval flat stones for this project. You can also use some stones with irregular shapes to create a different effect. Start by sketching on your stone's natural surface with a pencil, taking inspiration from the motifs of different cultures. Or, draw different shapes and forms completely from your imagination.

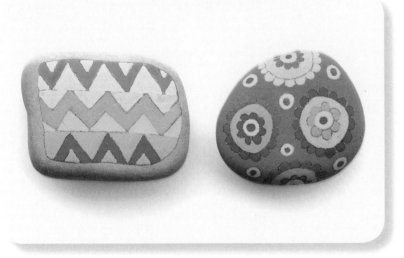

2 Then, using paint pens or acrylic inks, add color to your designs. This project provides a great opportunity to experiment with many colors.

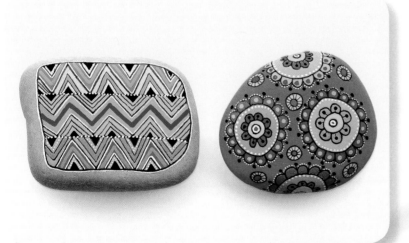

3 Add some contour lines to your designs with a black fineliner pen. To finish your folk or abstract design, add details with a black fineliner pen and paint pens. As always, you can use lines, dots, triangles, leaves, semi-circles, waves, or lines to fill your design. More details will give a richer look to your design.

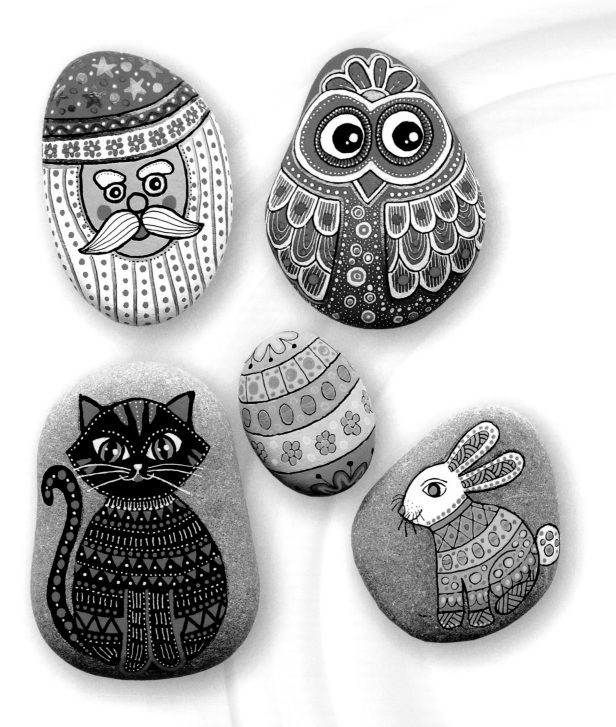

Festive Times

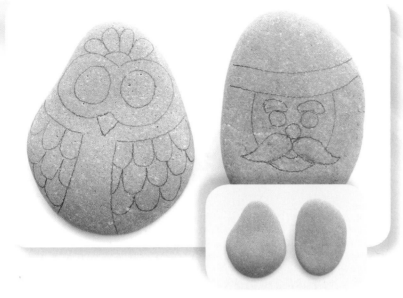

1 When the festive days of Christmas, Easter, and Halloween are near, you may want to paint some stones with these themes. This project will provide some ideas about what to paint. Look for oval-shaped, smooth stones for your owl and Santa designs. Simply outline your designs on the stones with a pencil.

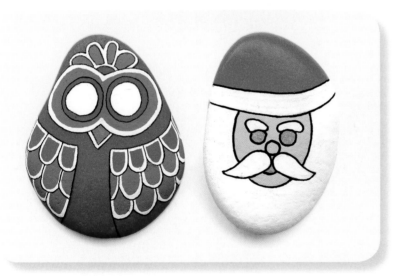

2 Then paint them with Christmas colors such as green, red, white, and gold. As always, add a contour line to every part of your design with a black fineliner pen.

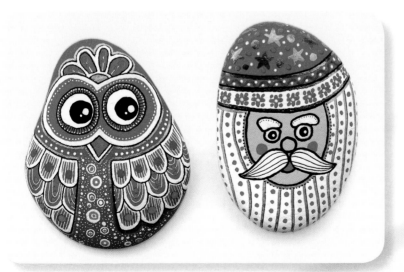

3 For a richer look, add dots, lines, gold stars, or small crosses to your designs. Use paint pens, gold inks, or fineliner pens.

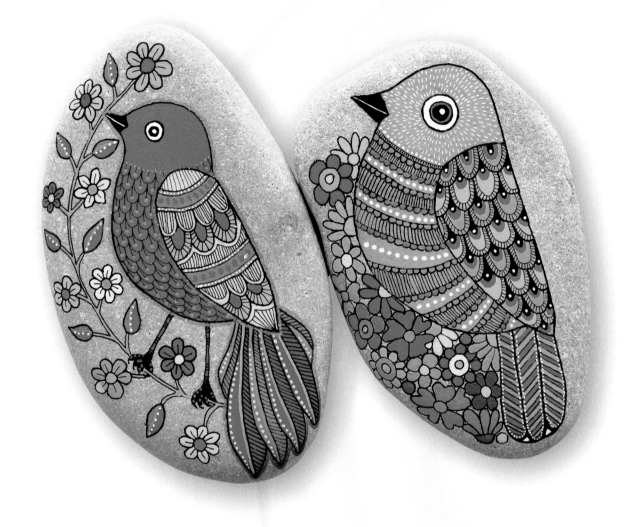

Fanciful Birds

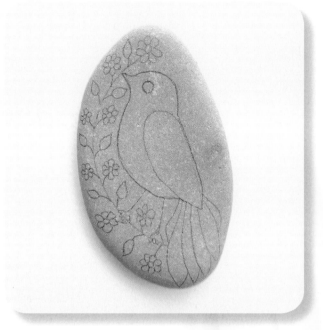

1 You will need an oval-shaped, flat stone for this project.

2 Using a pencil, draw your bird's sketch on the stone. You can draw a simple bird, or you can add all the details in this phase.

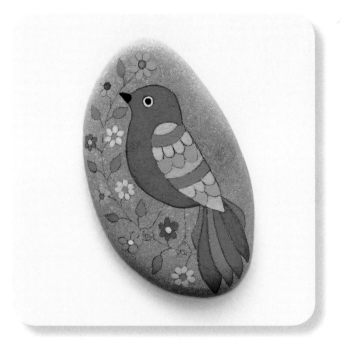

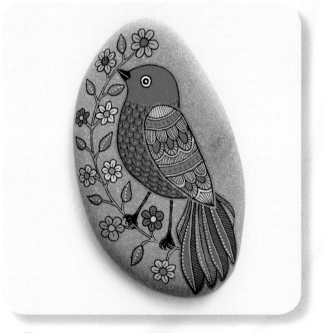

3 Paint your bird with the colors and media you want to use. Here, I used acrylic inks with thin round brushes for larger spaces, and paint pens with extra-fine tips for the smaller outlines.

4 After your paint dries (about 30 minutes), you can start to add more detail to your designs. Use thin parallel lines, dots, and half circles to fill your bird's body and feathers. Try adding small flowers for a stylish look. For all details, you can use extra-fine liner pens with waterproof inks, or you can use dip pens with acrylic inks or extra-fine-tip paint pens.

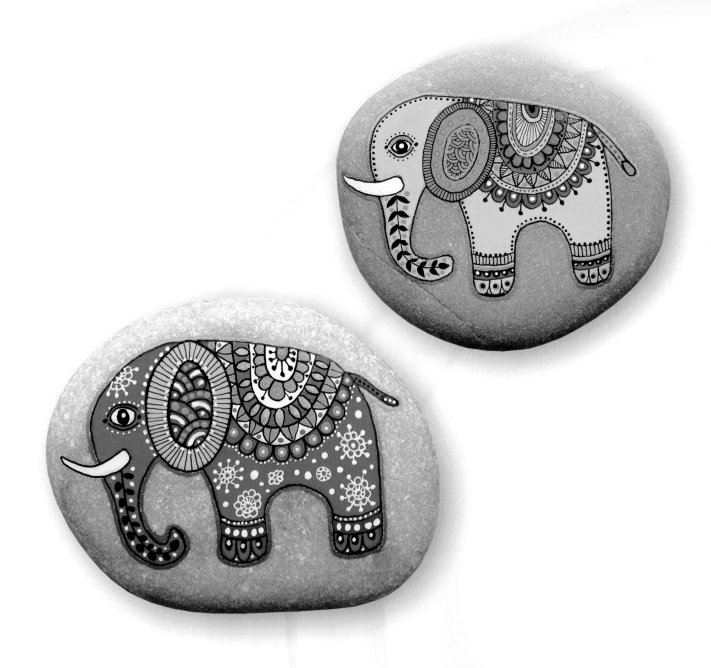

Eye-Catching Elephants

1 Colorful elephant designs are very suitable to paint on flat, large stones that have a smooth surface. You can paint your stone's surface with the background color of your choice, or you can work directly on its natural surface. First, find an oval-shaped, large, flat stone.

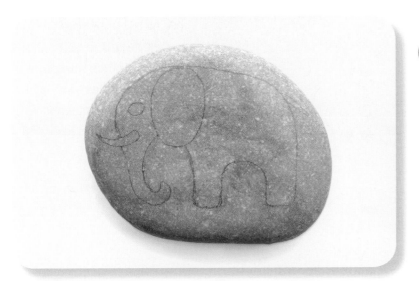

2 Using a pencil, draw your elephant's sketch on the surface. You can draw an outline of a simple elephant or you can add all the details in this phase.

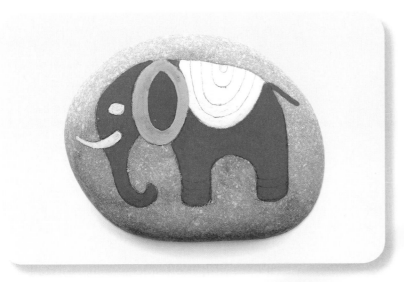

3 Start to paint your elephant with the colors and media you want to use. Here, I used acrylic inks with thin round brushes for larger spaces, and paint pens with extra-fine tips for small details.

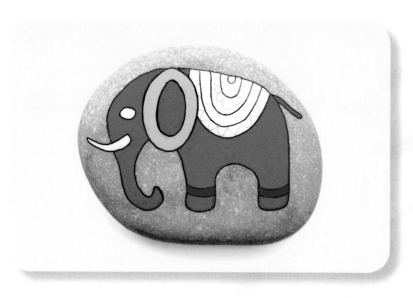

4 Add contour lines with black fineliner pens.

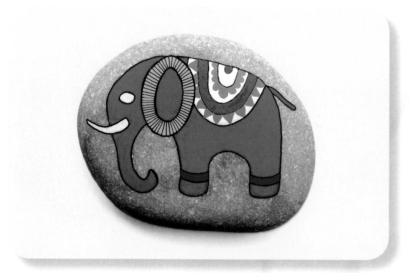

5 Start to add details to your designs. You can use thin parallel lines, dots, and half-circles to fill your elephant design. Try adding small linear flowers to give a stylish look to your elephant.

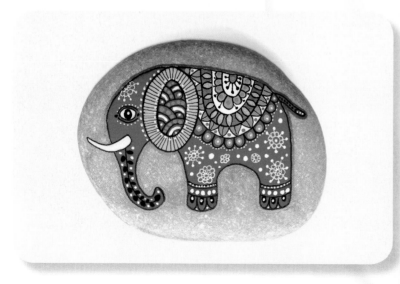

6 For all details, you can use extra-fine liner pens with waterproof inks, or you can use dip pens with acrylic inks or extra-fine-tip paint pens.

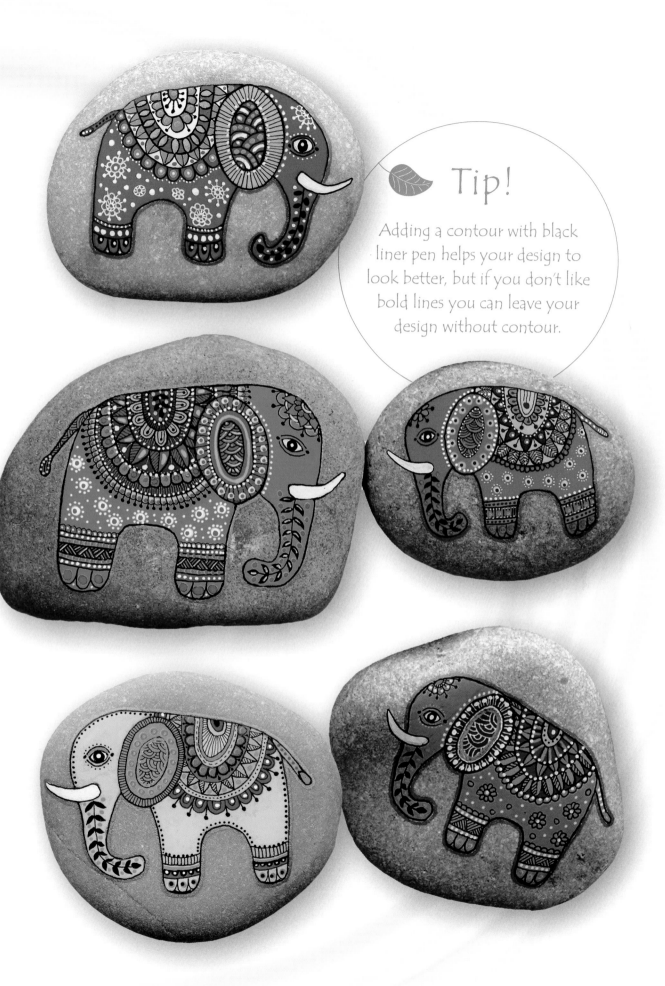

Tip!

Adding a contour with black liner pen helps your design to look better, but if you don't like bold lines you can leave your design without contour.

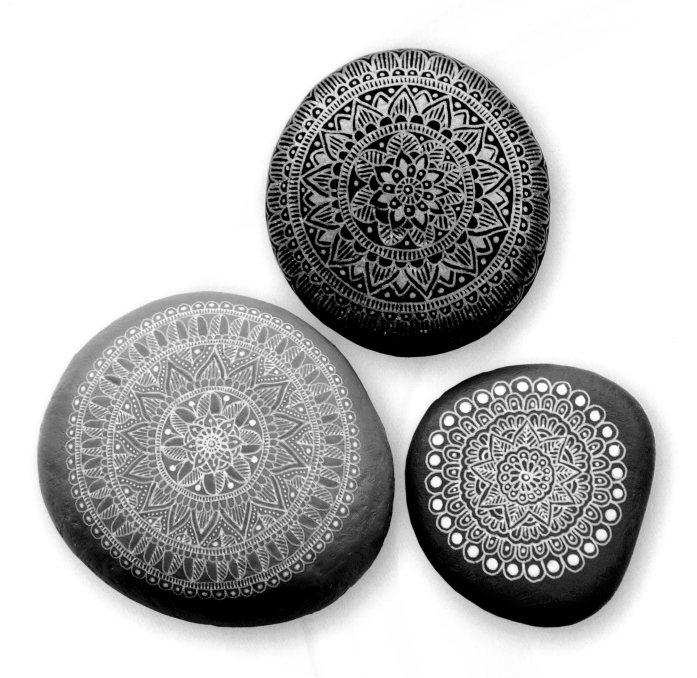

Monochrome Mandalas

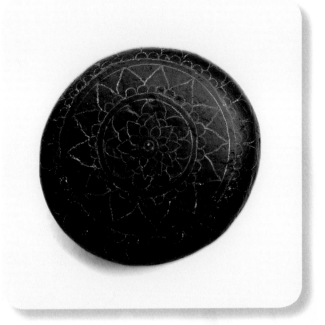

1 A round stone with a smooth surface will be fine for this design. Here, I painted its surface with black acrylic paint. If you can find naturally darker stones it is better.

2 Then draw your mandala details with a white pencil on the stone. It is not necessary to draw all the details now—you can add them later.

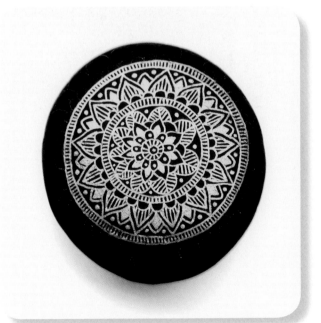

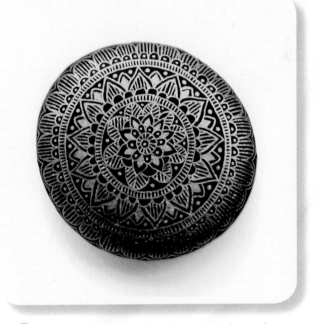

3 Start from the center to pass over all outlines with a dip pen using acrylic gold ink.

4 Try to work slowly when you draw the lines and circles, and with a steady hand. Make sure your start and stop points meet each other.

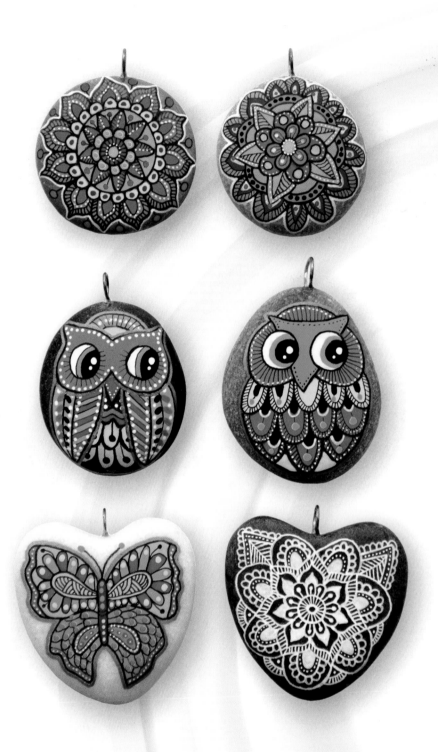

Pebble Pendants